IMAGES
of America

PACKARD MOTOR CAR COMPANY

IMAGES
of America

PACKARD MOTOR CAR COMPANY

Evan P. Ide
Foreword by Joseph S. Freeman

ARCADIA

First printed in 2003.

Published by Arcadia Publishing,
an imprint of Tempus Publishing Inc.
2A Cumberland Street
Charleston, SC 29401

Printed in Great Britain.

Library of Congress Catalog Card Number: 2003103753

For all general information, contact Arcadia Publishing:
Telephone 843-853-2070
Fax 843-853-0044
E-mail sales@arcadiapublishing.com

For customer service and orders:
Toll-free 1-888-313-2665

Visit us on the Internet at www.arcadiapublishing.com.

CONTENTS

Acknowledgments 6

Foreword 7

Introduction 9

1. Warren, Ohio 11

2. Detroit, Michigan 33

3. The Twin Six 63

4. Postwar 73

5. The Classic Era 87

6. Racing Packards 123

ACKNOWLEDGMENTS

This book would not have been possible without the help of several individuals. Doug Olsen and Katherine Flach provided a great deal of assistance with the organization and execution of the book. Thanks to Joe Freeman for his foreword and to John Sweeney and the rest of the museum staff for their help and encouragement. Thanks to Frank Gardner for his information on Rod Blood and for his foresight in seeing that the museum receive this collection in 1966. Thanks also to Jim Cypher for getting the ball rolling and to Jennifer Hayes for all her editing, scanning, and patience.

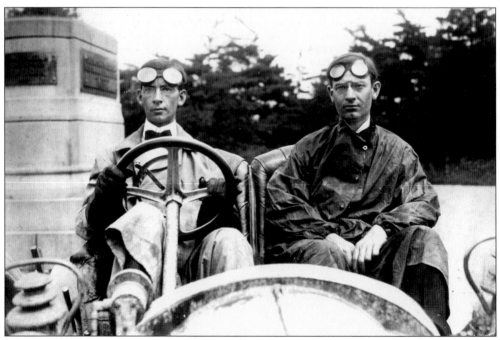

Early motorists are shown at the wheel of their Packard roadster.

FOREWORD

Packard enthusiast and collector Roderick Blood acquired a dusty filing cabinet full of early Packard automobile photographs and documents from an unidentified man in Detroit. The materials were salvaged from the Packard plant when the company closed its doors in 1957. Blood traded a Packard automobile for the collection, which he believed to be an important discovery. The cabinet contained a rich archive of original photographs belonging to James Ward Packard. In addition to the hundreds of early photographs, there were Packard company correspondence, letters from James Ward Packard, company manuscripts, and other records. Upon Blood's death in 1966, the entire collection in the original factory filing cabinet was given to the Larz Anderson Auto Museum, in Brookline, Massachusetts. The auto museum, America's oldest, began as a collection of automobiles in 1899 and is still housed in its late-19th-century carriage house in Brookline. The historic Blood-Packard collection has never been published or even displayed, having been relegated to backroom archives and often eclipsed by more popular or glamorous automotive artifacts over the years. Recently, the Blood-Packard collection was rediscovered by museum curator Evan Ide. The importance of the Blood collection is that it contains early factory photographs of Packard automobiles, most of which were thought to have been lost forever. We are pleased to bring this collection back into American automotive history and to make them available for public enjoyment.

Joseph S. Freeman
President
Larz Anderson Auto Museum
Brookline, Massachusetts

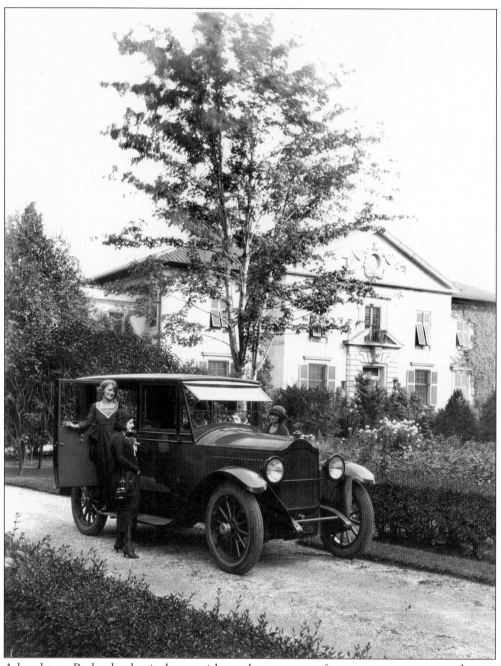

A handsome Packard sedan is shown with an elegant group of passengers near a manor house.

INTRODUCTION

The Packard Motor Car Company holds a unique position in the history of the American automobile. Esteemed among automakers, Packard was able to survive the Great Depression and two world wars—periods that were fatal to many of Packard's competitors. The Packard marque even enjoyed a perception of status above America's flagship brands—Lincoln and Cadillac. Equals were Pierce Arrow and Peerless, who (with Packard) formed "the three Ps," America's finest automakers. Peerless and Pierce Arrow faded early, but Packard continued on until 1957, when the company finally closed.

The first Packard was built in 1899, and the company soon surpassed the thousands of other small manufacturers in the early days of the auto industry. The Packard Motor Car Company set itself apart almost immediately with the highest quality of style and engineering. The trademark shape of the Packard radiator shell was as distinctive as Rolls-Royce's, and it became recognizable to admirers worldwide. Eventually, even Russian manufacturers selected the Packard as the basis for production of their luxury car line. Packard continues today to be one of the most sought after collector cars in the world market. Enthusiast groups around the world continue to sustain the Packard legacy. This collection of photographs is important for several reasons. Many of these images have never been published and have not been seen outside of our museum. The factory intended to use these photographs to document its corporate history, and James Ward Packard collected many of them personally.

The images present vehicles in a changing social context. An elegant Packard parked in front of a fine manor house created an association with wealth and prestige that was eventually to characterize the lifestyle of the Packard owner. But Packards were also built to be driven, and Packard's many road triumphs, such as ascending Mount Washington, driving in 1,000-mile endurance tests, and journeying through a treacherous and young landscape over numerous unpaved roads, are all photographically documented here.

Photographs of these automobiles show us a great deal about how America was changing both socially and physically. The change in roads and infrastructure dramatically changed the look and purpose of the automobile. No longer just an elegant carriage for trips to the opera,

the automobile became a highly practical necessity of modern life. By following the evolution of these images, one can see how the automobile developed and how owners' relationships with their vehicles evolved.

These photographs give us a visual history that words alone cannot. Much can be gleaned from these pictures if the time is taken to examine all they have to reveal. Please look carefully at these rare images and let them tell you the story of a truly great company and automobile.

<div align="right">

Evan P. Ide
Curator
Larz Anderson Auto Museum
Brookline, Massachusetts

</div>

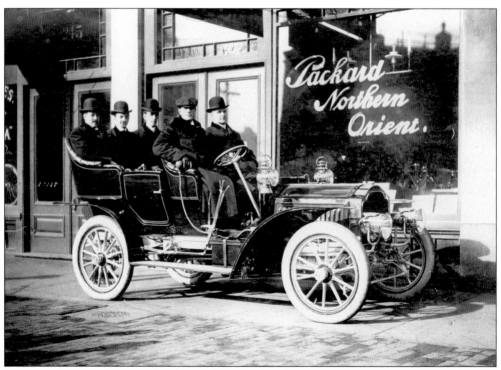

A group of motorists in a Packard touring car poses in front of a Boston dealership.

One
WARREN, OHIO

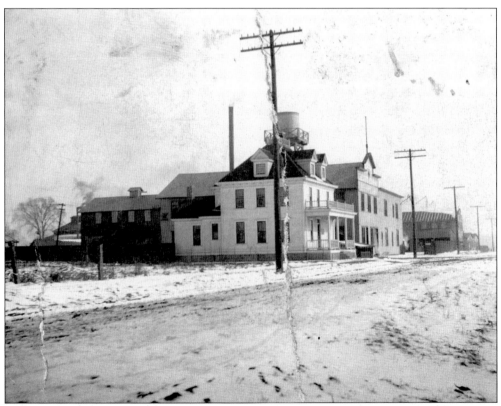

Shown here is the New York and Ohio Company in 1898, at its Warren, Ohio facility. James Ward Packard and his brother William produced electric bells, dynamos, and lamps starting in 1895. This small factory would eventually produce the first Packard automobiles here in Warren, where Packard would remain until 1903.

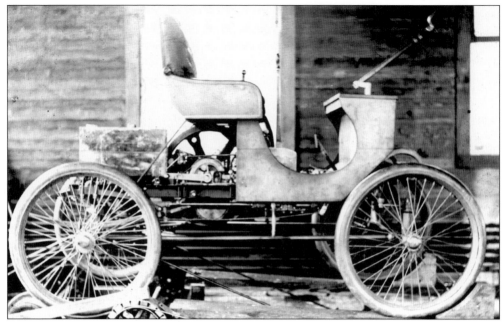

A prototype Packard Model A from November 1899 is shown in this photograph. This is likely the first vehicle built by Packard, and it is shown attached to an early dynamometer unit that measured horsepower. Packard produced four Model As in 1899, and it is said that James Ward Packard built this car out of dissatisfaction with a Winton motor carriage. When Packard returned his Winton to the factory due to constant mechanical problems, he was told to build a better car himself.

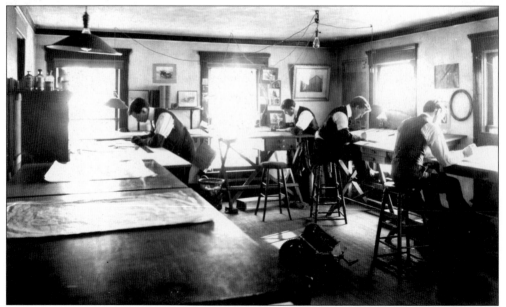

The drafting room at the Warren plant is pictured c. 1900. A team of draftsmen is working diligently to produce plans for automobiles. Thousands of such working drawings were produced entirely by hand in order to build a car. On the floor, an early sliding gearbox and differential can be seen.

This view shows of a prototype Packard Model C. The Model C is distinguishable from earlier models by the steering wheel, which replaced the tiller system used on earlier cars. This photograph is dated 1900, but the Model C was not available until 1901. The Model C was the last Packard to be equipped with fragile wire-spoked bicycle wheels—subsequent models were equipped with wooden-spoked artillery wheels.

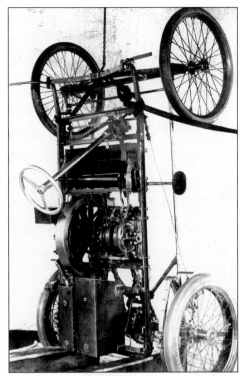

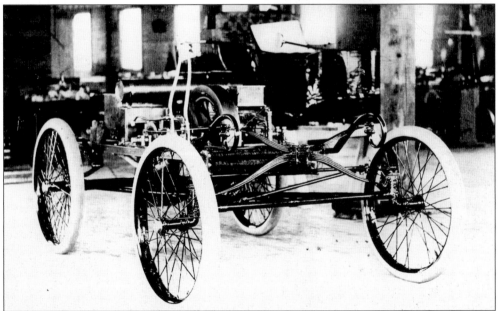

A front view of the Model B rolling chassis is shown here. A prominent feature of the Model B is the engine's flywheel with a diameter that rivals that of the tires. The early single-cylinder engines often had enormous flywheels to smooth out the engine and give the engine greater momentum. The simple radiator can be seen at the front left tucked under the car. Vehicle speeds were so low that cooling the engine was not difficult. The radiators were therefore rarely mounted on the front of the vehicle, as they are today.

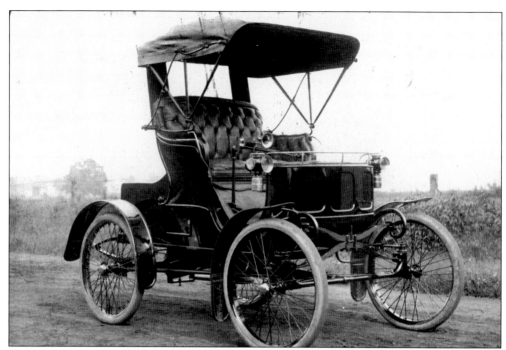

This Model B deluxe model is shown with intricate bodywork and the emergency seat in front with a railing around it. Forty-nine Model Bs were built, and they were equipped with several advanced features, including a foot-operated accelerator and automatic ignition advance.

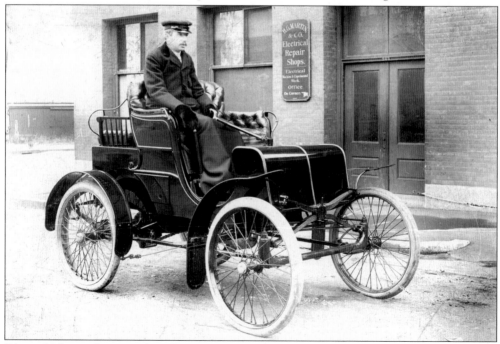

Edmund Bliss is shown at the tiller of a Model B in front of the Packard Electrical Factory in Warren, Ohio. Bliss is properly dressed for motoring on a cool day. A lap robe, driving hat, and driving gloves were necessary equipment in the days of open cars and dusty roads.

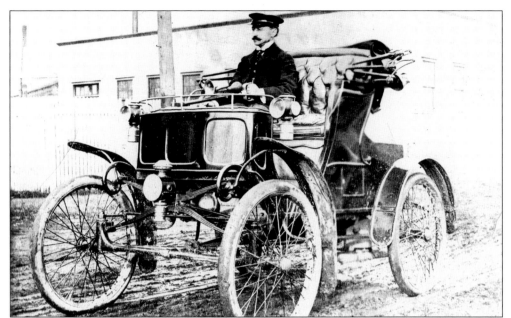

This photograph shows another image of Edmund Bliss at the wheel of the 1900 Model B. The elegant design and construction of the Packard are clearly seen with the elaborate curved chassis mounted on a twin set of semielliptical springs. The conditions of the roads in 1900 are also obvious from this photograph, with the vehicle's skinny bicycle-style tires stuck in the muddy road surface. Road conditions were a major problem for early motorists, and getting stuck in the mud and flat tires were regular occurrences.

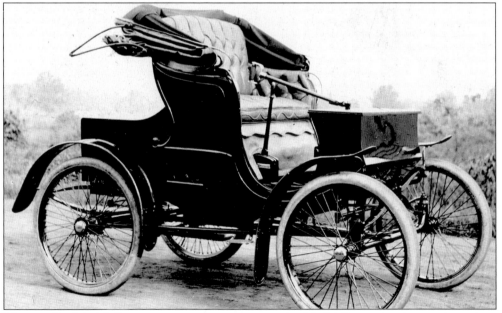

This smaller Model B is an interesting contrast to the Model B seen in the previous view. Despite the same model designation, this version was notably different with its compact, lighter springs and a much lower stance. Patent leather fenders were the norm in the early days of auto making, as very little metal was used in coach building at this point.

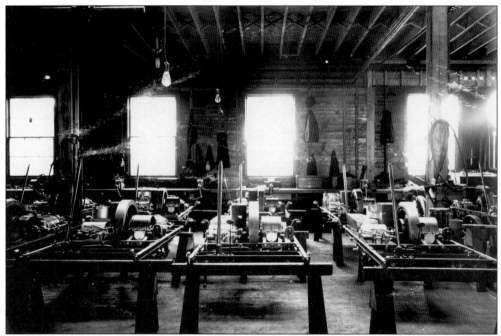

This interior view of the Packard factory *c.* 1900 shows a group of Model C Packards during assembly. In total, 81 Model Cs were built and sold in 1901. This photograph also illustrates the straightforward nature of early automobile production.

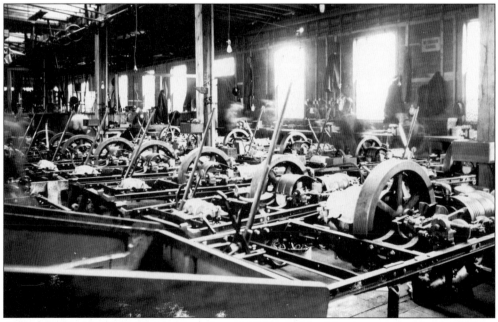

Although the Model C was designated as a 1901 model, this photograph (dated 1900 by Mr. Packard) shows a group of 12 Model Cs being produced. Early on, Packard began the practice of introducing his next year's models in November. Henry Ford's assembly line was years away, but the Packard factory had its own form of automation. By working on a dozen cars together, workers could efficiently assemble vehicles in large batches.

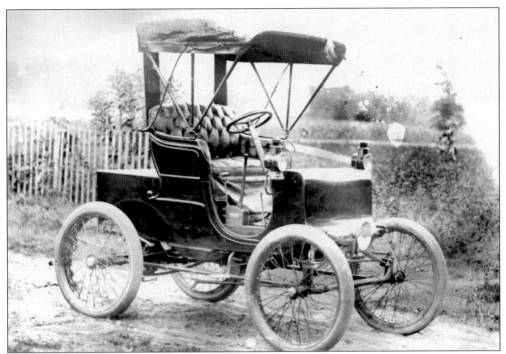

A completed Model C of 1901 is shown here. The most obvious difference from the Model B is the replacement of the tiller with a steering wheel. Steering wheels were still uncommon in cars of the time, and Packard's adoption of them in late 1900 was innovative.

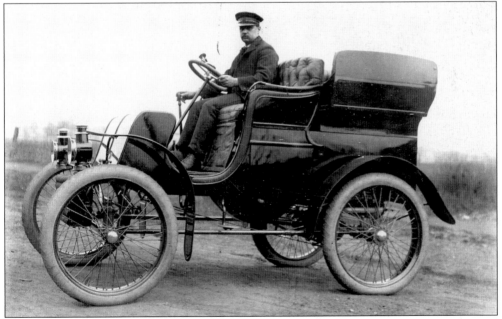

This six-passenger 1901 Packard Model C shows the unusual rear entrance tonneau and sideways passenger compartment. While this design did allow for six passengers on a relatively short chassis, this type of seating had short-lived popularity, probably due to the overly intimate seating of four in a very small area.

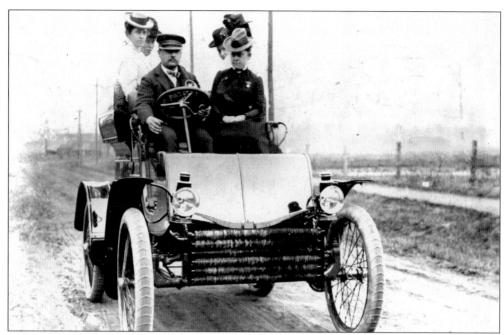

William Hatcher is shown at the wheel of the 1901 Model C along with Packard's sister Olive and other Packard employees. The six-passenger tonneau placed the occupants a considerable distance off the ground. This Packard is equipped with an extra-large front-mounted radiator, probably due to the extra weight of the six-passenger body.

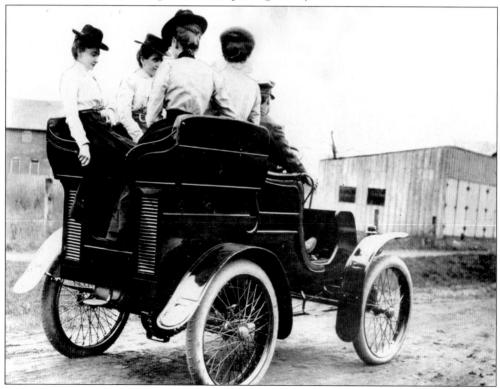

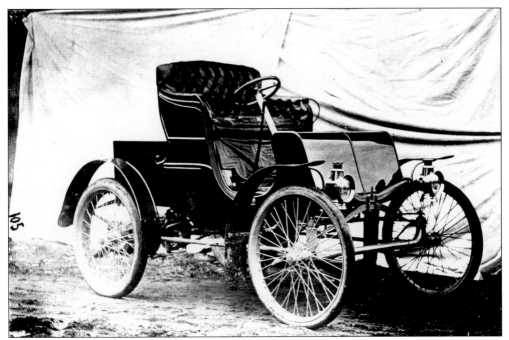

A straightforward Model C is shown outside the Warren, Ohio factory. A simple sheet is held up behind the car for what would probably become a publicity or catalog photograph—the photographers were apparently not too concerned with the muddy road.

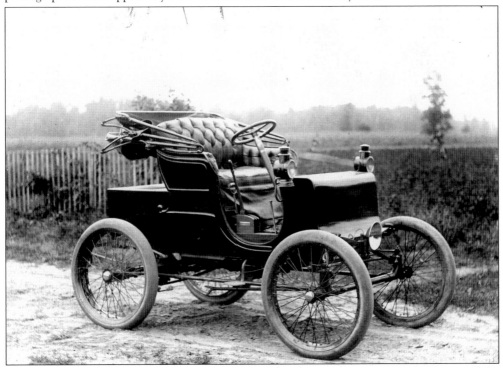

Fresh out of the factory, this handsome Model C runabout is, in many ways, reminiscent of the Winton runabout that was James Ward Packard's motivation to begin producing cars.

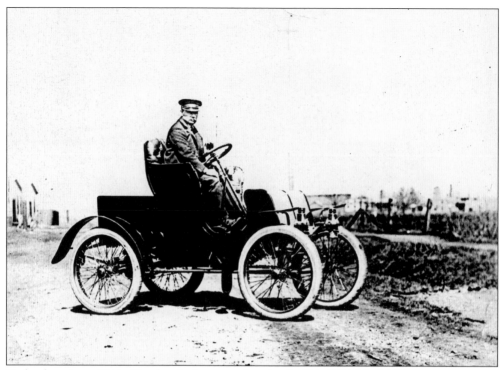

Packard engineer W.A. Hatcher is shown at the wheel of his 1901 Model C.

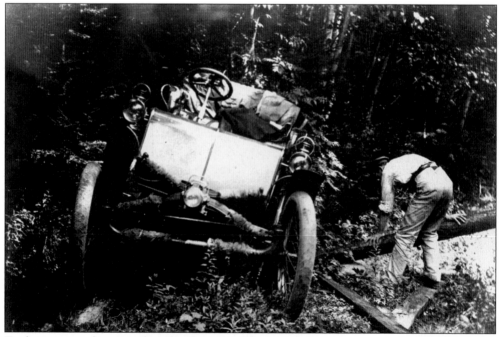

To demonstrate the strength and endurance of their product, early car manufacturers would put their vehicles up to great challenges. Shown here is a Packard Model C ascending Mount Washington, the highest peak in the Northeast. At the time, this Packard was the fifth vehicle to manage the grueling passage.

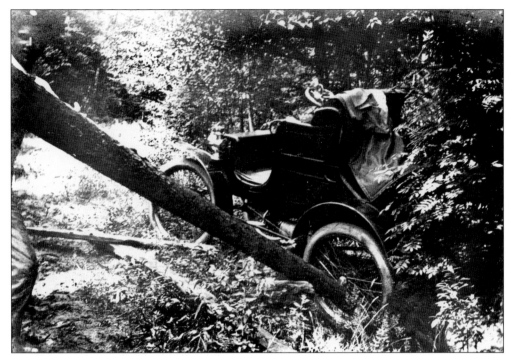

The adventurous driver is seen using the tools at hand to free his Model C. The Model C would successfully make it to the top of Mount Washington—although not without challenges.

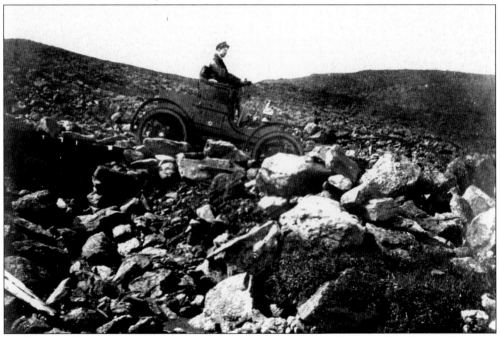

Shown is a less treacherous moment in the Packard's journey to the summit of Mount Washington. The Packard's completion of this grueling trip was an impressive achievement, as most of the vehicles put to such a challenge were steam powered and produced more usable power for climbing steep grades.

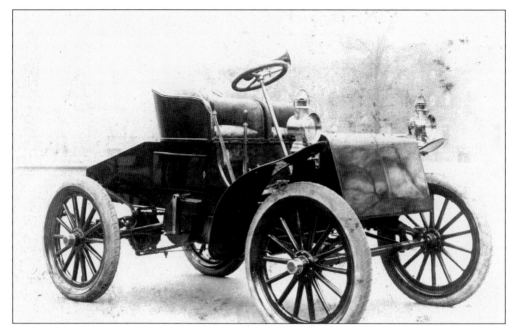

Packard bypassed the model designations of D and E and went straight to the Model F in 1902. The most noticeable difference is the replacement of the wire-spoked bicycle wheels with more rugged artillery wheels. The Model F's chassis was lengthened, and the new Packard looked less like a horseless carriage.

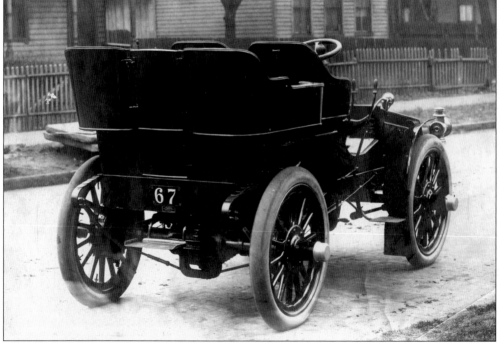

The lengthened Packard chassis could better accommodate multipassenger seating. No longer was there a need for awkward face-to-face seating as with the six-passenger Model C, and four could sit in comfort with ample legroom.

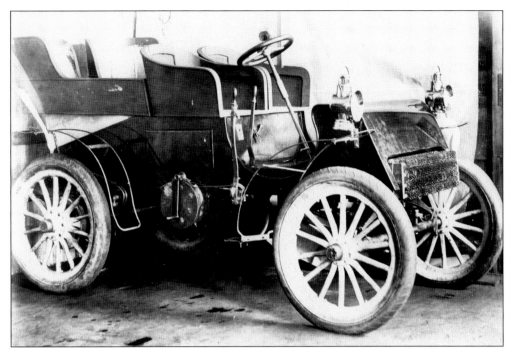

This is a factory picture of a Model F either in mid-production or one used for testing purposes. There is no interior upholstery or leather on the fender frames. Because of the mid-mounted engine, the starting crank for this model, and all models up to this date, is on the side.

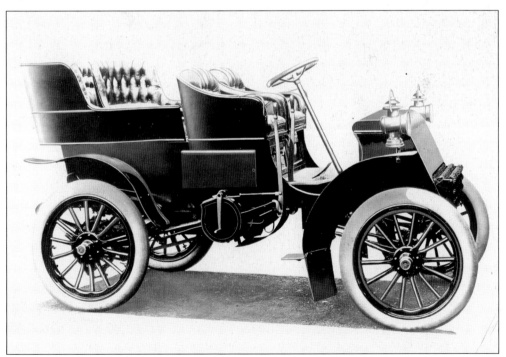

Mr. Packard's personal car was a custom-bodied Model F. The vehicle was nicely equipped with dual acetylene headlamps and an unusual high-mounted rear seat.

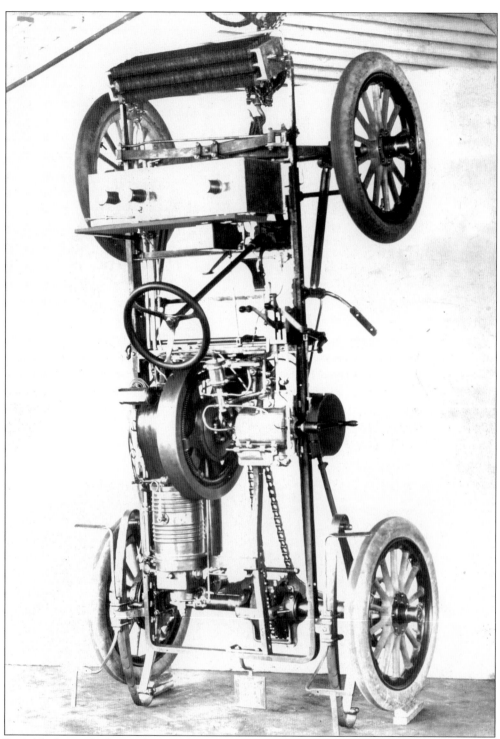

Probably due to the low ceilings at the Packard factory, overhead chassis shots like this Model F were taken by suspending the chassis from the ceiling. The giant single-cylinder engine is a dramatic contrast to today's engines.

24

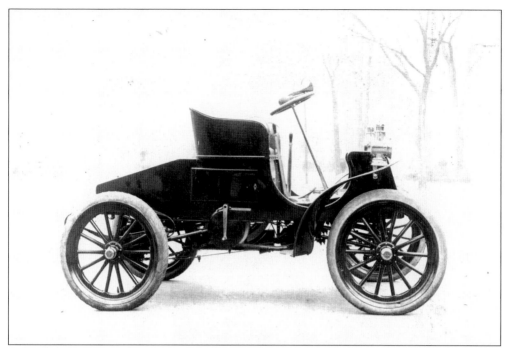

A handsome 1902 Model F is shown in front of New York's Washington Square. Photographs of cars placed in elegant settings like this were generally used for brochures and advertisements.

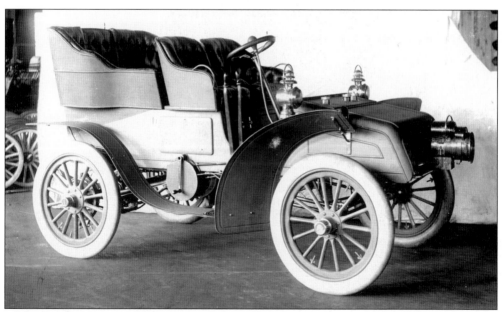

Packard updated the Model F for 1903, with the biggest change being the integration of the radiator tubes into the front of the car's body. By this time, the car's appearance was becoming more modern and refined. The cowl by the side oil lamps offered convenient filling of the necessary oil, gas, and water. In the early days of motoring, cars consumed great quantities of oil and water in addition to gasoline. When a car's gas tank was filled, the other fluids were always filled at the same time.

This rear view of the revised 1903 Model F shows the removable flat panel at the rear that would allow a multipassenger tonneau to be fitted in its place. A single oil-powered taillight was standard equipment, and fenders were now being produced from formed steel instead of patent leather.

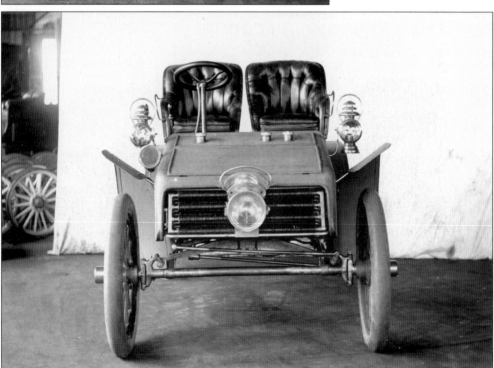

This front view of the Model F shows its very clean and uncluttered appearance.

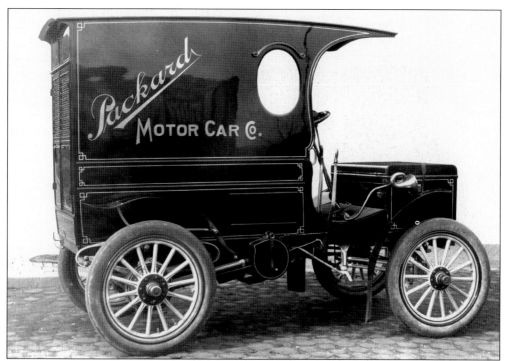

This photograph of a 1903 Packard Model F delivery truck was long thought to be lost. Probably used by the factory for utility and advertising, only one example of this handsome little delivery wagon is believed to have been produced.

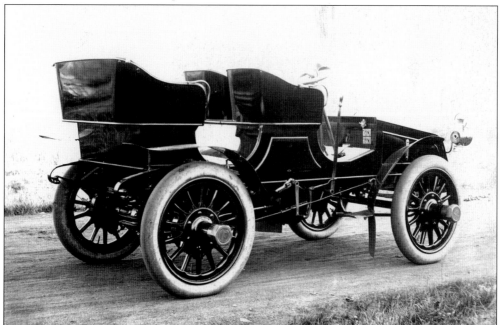

The 1903 Model G featured Packard's first multicylinder engine. The car's two-cylinder engine produced 24 horsepower and powered a chassis with a 91-inch wheelbase. The enormous hubs on this model are almost comical in their appearance but suggest the robustness of the chassis.

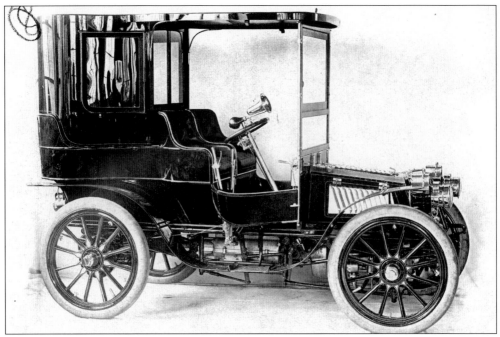

As one of the first enclosed Packard passenger cars, this 1903 Model G is fitted with an elegant glass canopy to keep out the elements. This model is also equipped with peculiar little doors in the chauffeur's area.

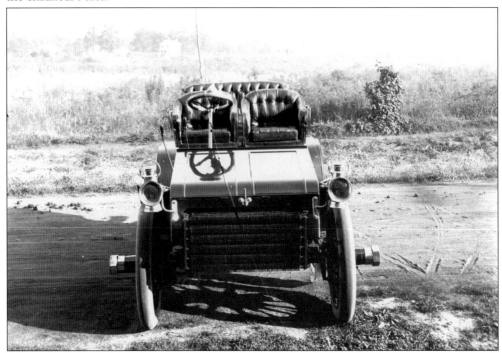

This front view of the Model G shows the large-tube radiator used to cool the two-cylinder power plant. The enormous hubs look even bigger from this angle, but they were effective at keeping other vehicles from getting too close to the car.

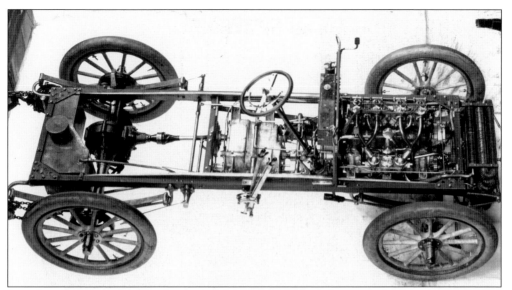

Introduced in 1902, the Packard Model K was a radical departure from previous models. Borrowing almost nothing from prior models, this front-engine, shaft-drive chassis was very modern. With all this innovation came a great price—starting at $7,000, it was three times the price of any prior Packard model.

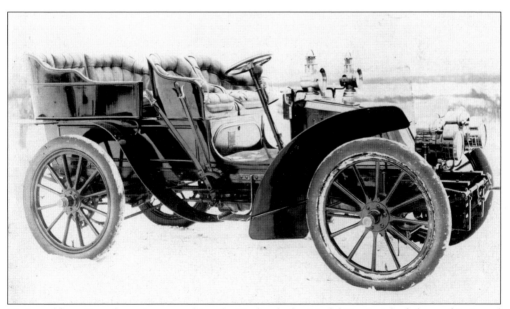

Designed by a French engineer working for Packard, the Model K mimicked the sophisticated French cars of the era. The design proved to be very complicated and was abandoned in favor of the simpler Model L.

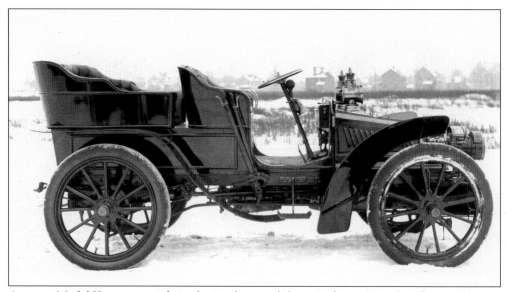

An open Model K tonneau with its sloping front end shows its heavy French-influenced design.

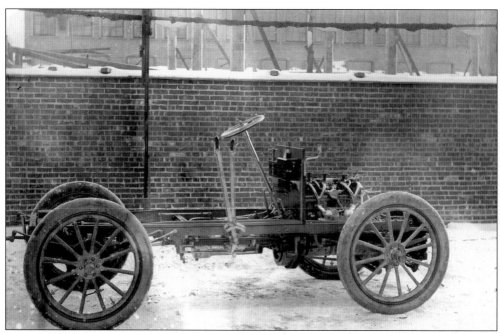

The 1903 Model K, shown in the snow, was the flagship of Packard's line and was one of the most expensive American cars available. The car was plagued with problems, however, and Henry Joy, Packard's president, despised the car for its complexity.

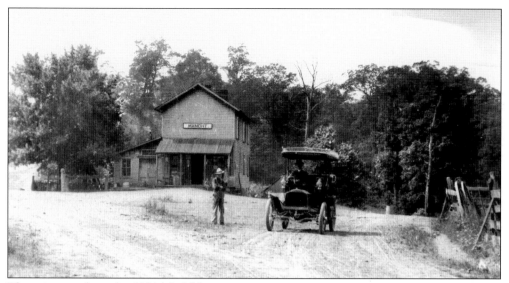

These images show the 1904 Model L in some sporting scenes.

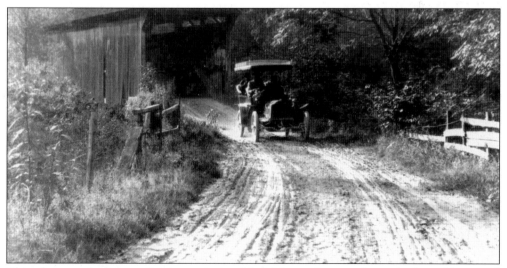

This photograph shows a fixed-top touring Model L coming out the end of an old covered bridge. The dusty dirt roads were the norm for the time this photograph was taken.

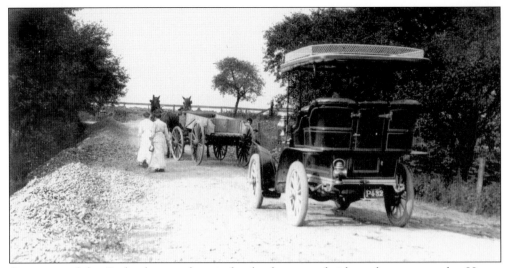

Occupants of this Packard patiently wait for the farmer to finish so they can pass by. Horse-drawn wagons in the road were common obstacles that early motorists had to contend with.

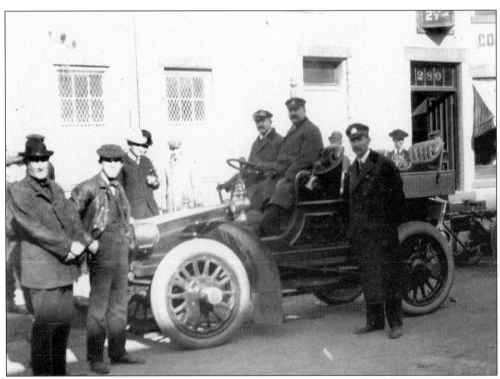

Harlon Whipple used his Model K on a New York–Boston run, which proved to be a real achievement in 1903. There were few good roads, fewer road signs, and a limited number of places to buy gasoline.

Two
DETROIT, MICHIGAN

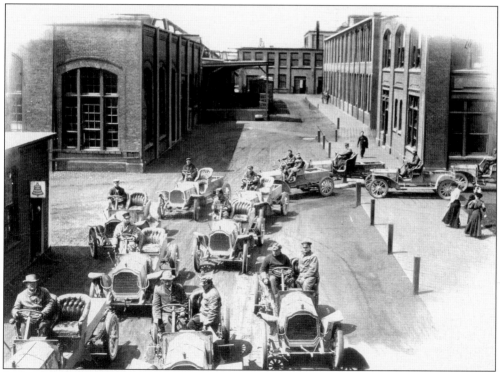

Packard moved from Warren, Ohio, to Detroit, Michigan, in 1903, where the company would stay until the end. The new, larger factory enabled Packard to produce a higher volume of more sophisticated cars. The first model out of the Detroit factory was the Model L. Seen here is a group of test vehicles motoring around the factory.

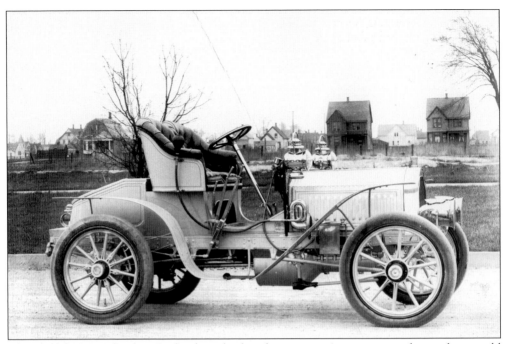

The Model L was the first Packard to display the company's signature radiator that would become synonymous with the brand throughout its history. In only four years, Packard motorcars had evolved dramatically.

Packard realized that the Model L was a truly practical and durable automobile. Eager to test the design, the factory attempted a 1,000-mile, nonstop endurance test. Unfortunately, driver Jack Boyd was unsuccessful in his attempt.

Six hundred miles into his record attempt, Jack Boyd tangled with a fence pole—with disastrous results.

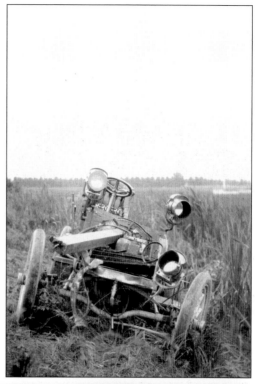

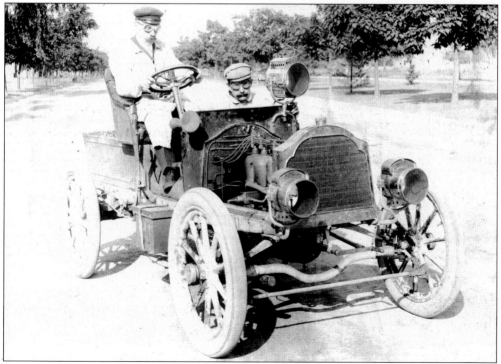

Soon after Jack Boyd's ill-fated attempt, the determined team of Eddie Roberts and Charles Schmidt achieved the goal at an average speed of 33$\frac{1}{2}$ miles per hour.

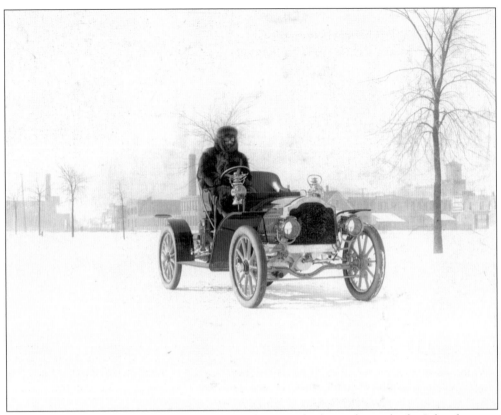

The Model N appeared in 1904 with a longer chassis and a larger four-cylinder L head engine than the Model L. Additionally, the Model N was offered in a much wider range of body styles. Pictured here is the Model N sporting roadster with a properly dressed driver in bearskin coat and goggles.

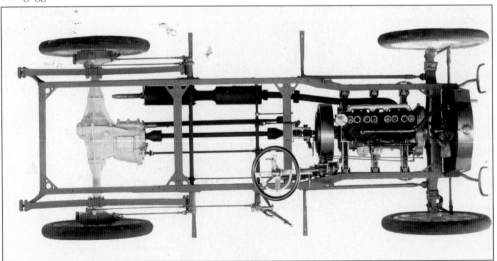

An overhead view of the Model N chassis shows how greatly simplified it was in contrast to the Model K. The only major mechanical difference between it and the later Packards is the rear transaxle, where the transmission was housed.

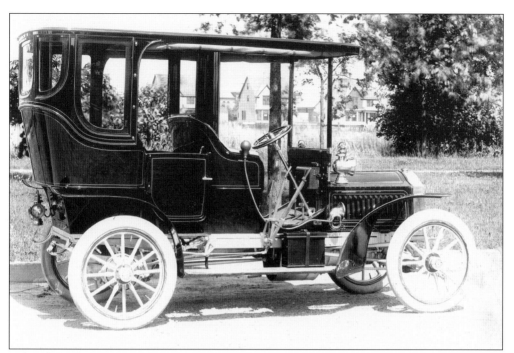

A handsomely bodied Packard Model N limousine is shown with roll-down side curtains and division glass between the chauffeur and the rear passengers. This model looks as though it might be "convertible," meaning the glass sections could be removed for summer motoring.

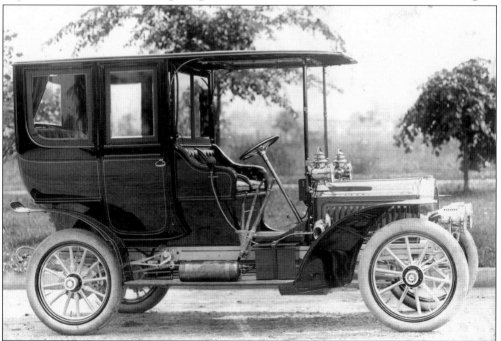

This elegantly appointed limousine was the type of vehicle that was becoming quite popular with the wealthy set. Packard was going after the same high-end customers who were buying the exotic foreign-built cars, and this limousine was quite European in its appearance.

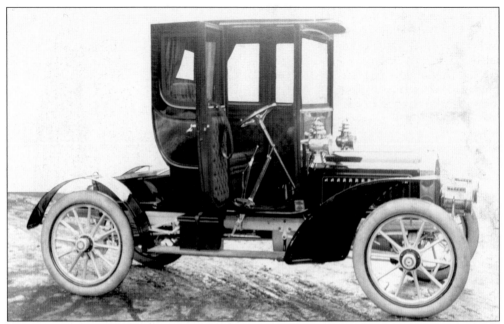

A 1905 Packard Model N coupe, although rather strange to the modern eye, would have been considered very fashionable in 1905. Note the straps for raising and lowering the door windows as well as the rich upholstery that is evident by the luxuriously tufted door panels.

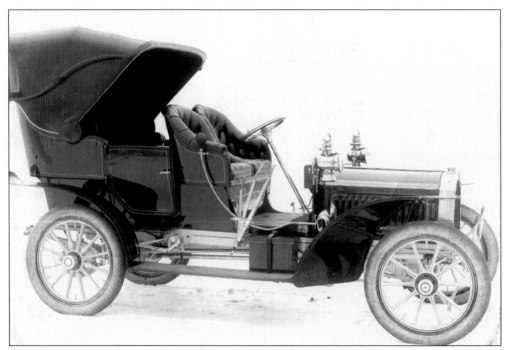

The 1905 Model N Victoria was another type of body that was offered on the versatile Model N chassis. The Victoria was a fashionable body style directly related to a carriage of the same name. Its efficiency is questionable, as the Victoria top would act like a giant parachute.

This overhead view of the Model N controls shows the center-mounted throttle pedal that might prove unsettling to today's drivers. The controls for spark timing and throttle control are located on the steering wheel.

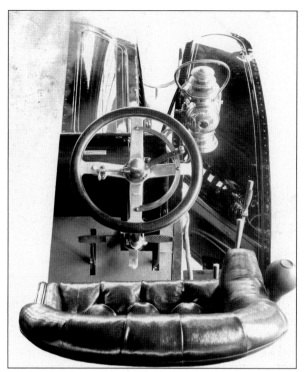

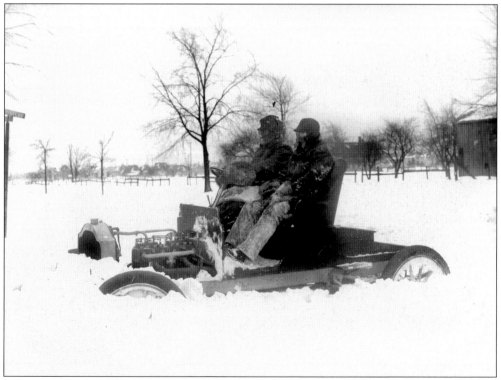

Judging by the lack of equipment on this Model N, this is very likely a pair of the company's test drivers who have gotten their Packard into a jam.

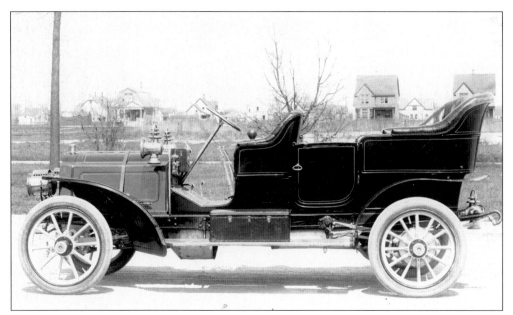

At the end of 1905, Packard introduced the Model S, or 24, shown here. This model represents Packard's introduction of its infamously complex numeric model-identification system. The Model S had the longest Packard chassis to date. At 119 inches, the car's chassis allowed for a wide range of bodies to be fitted on it. This touring tonneau gives one a sense for the spaciousness in the rear seating area.

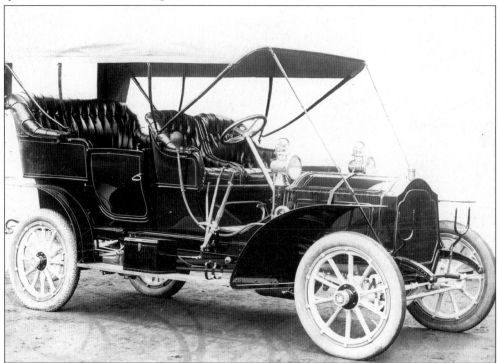

Elegant and handsomely appointed, the Packard Model 24 touring car was the definition of luxury.

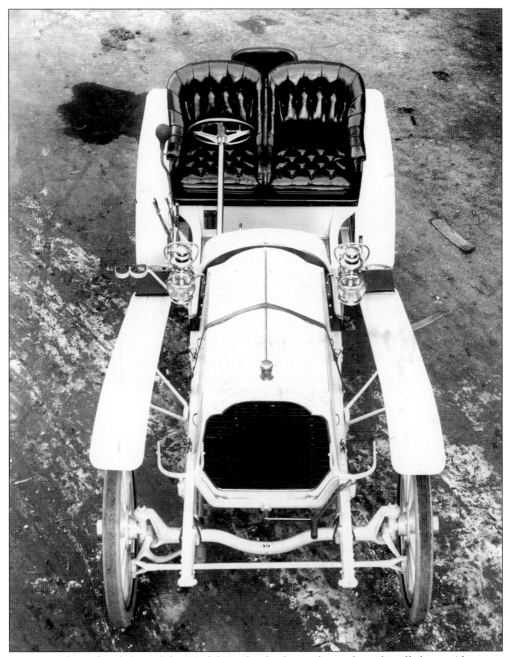

An unusual overhead shot of the Model 24 clearly shows the trademark grill shape. Also note the single rear seat, which was usually installed on roadsters and was affectionately called a mother-in-law seat.

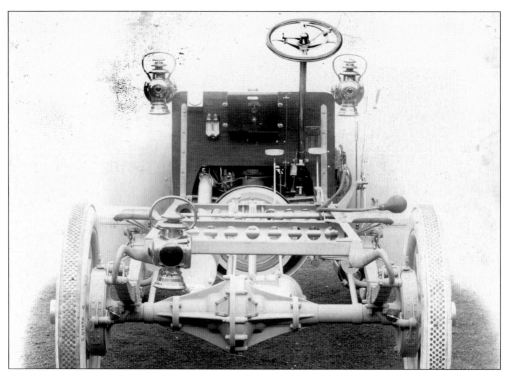

This rear view of a chassis shows how Packards were built like trucks, with huge leaf springs and thick, heavily reinforced rails. All this made for a very rugged and heavy car of exceptional quality and durability.

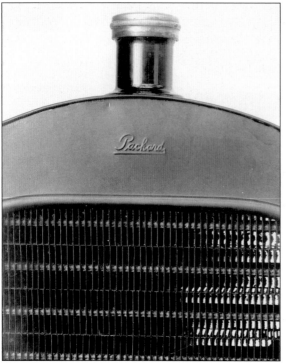

Surely there was a brass or nickel pour... would's the surround... this one?

This detail of the Packard 24 radiator shows its finned-tube design instead of the honeycomb configuration. With their understated logo, Packards could be recognized immediately by their world-famous radiator shape and did not need a lot of extra badging.

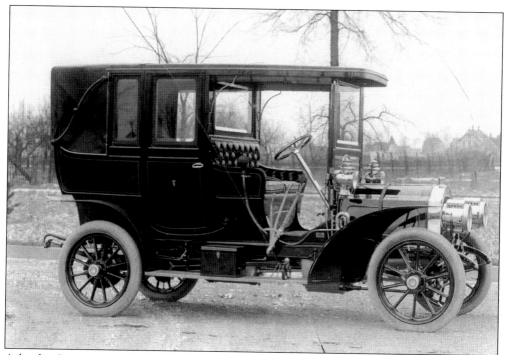

A landau Limousine Model 24 is another stylish European-type body on the Packard chassis. The landau top allowed the passengers to simultaneously enjoy the benefits of open-air motoring and privacy.

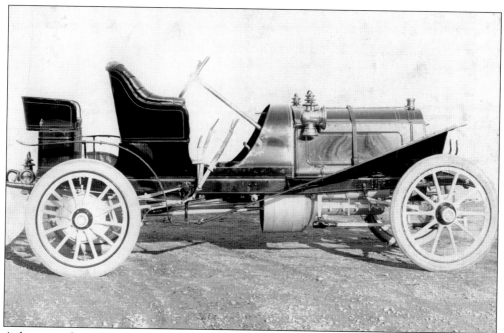

A departure from chauffer-driven Packards, this sporting roadster on the Model 24 platform was favored by wealthy customers who wanted to drive themselves.

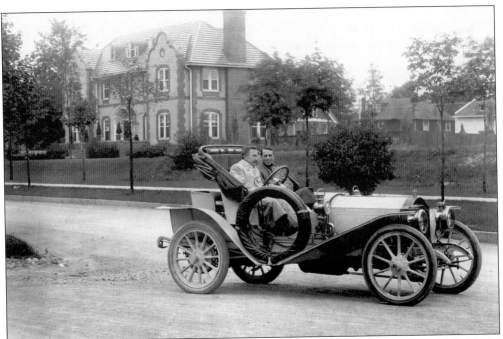

Company president Henry Joy (left) and Russell Alger are seen out for a drive in a 1907 Model 30 roadster. Joy kept a watchful eye over the product output, insisting the company's products be of the highest quality possible, and he frequently tested the vehicles himself.

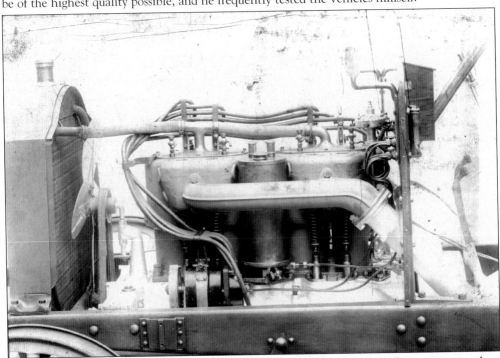

This detail of Model 30 engine shows the exposed springs and push rods that were normal on engines of this time period. The magneto shown on the lower left was also standard equipment prior to the development of battery-driven ignition systems.

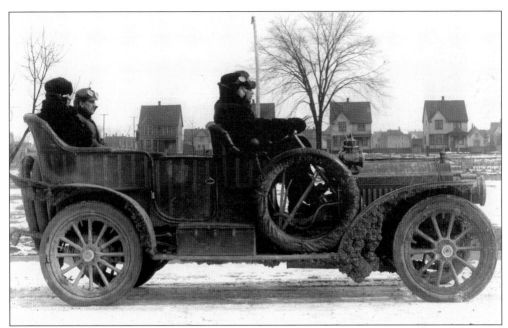

A chilly drive in a 1907 Model 30 touring car requires bearskin coats, goggles, and heavy gloves. Note the accumulation of ice in the front fenders and the vertical pinstriping on the bodywork.

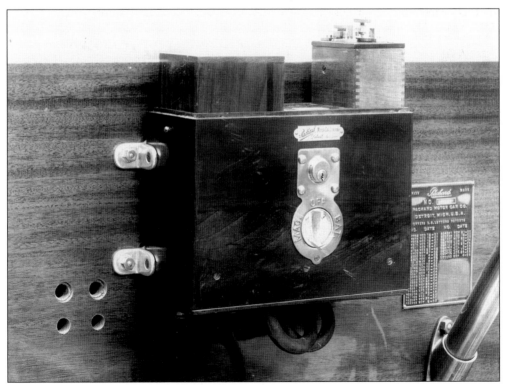

This view of the Model 30 dashboard shows the spark box with ignition key and the manufacturer's plate with all patent numbers on it.

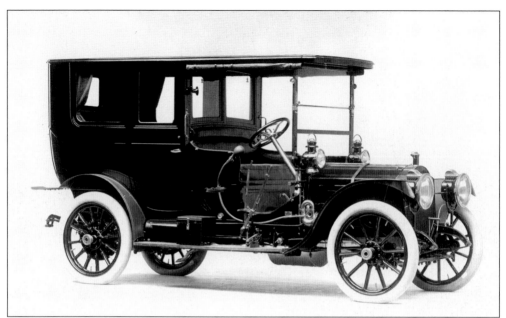

This handsome Model 30 from 1910 represents a classic Brass Era limousine. The term Brass Era refers to all cars built before World War I but is more often associated with cars displaying ample amounts of polished brass brightwork. This Packard, with its brass horn, headlights, radiator, steering column, and oil lamps, was built when brasswork was at the height of fashion.

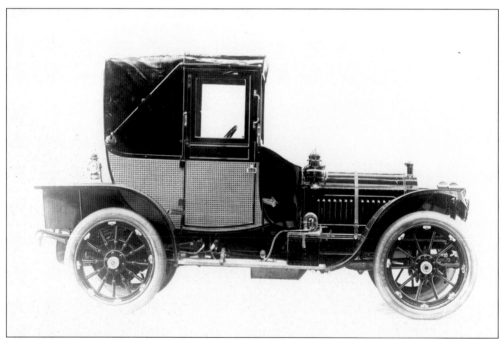

This 1910 Model 30 with convertible coupe coachwork was an unusual body style that shows off its lavish use of caning on the bodywork. This caning was either natural woven cane or simulated by tediously hand painting it on the body. This is yet another style that was carried directly from fine carriage and furniture design.

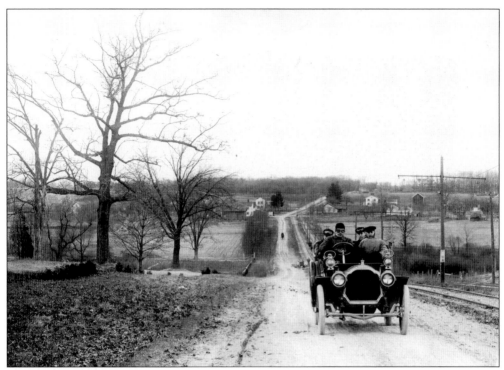

This photograph shows another cold-weather drive in a 1907 Model 30.

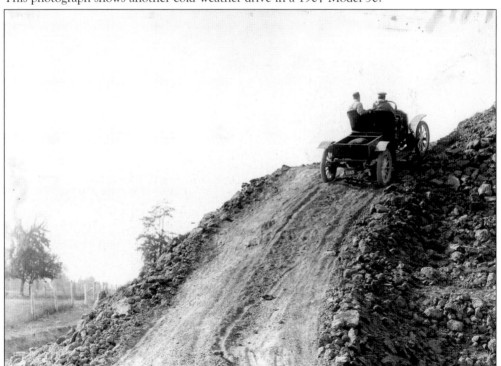

A view of the test facility shows a vehicle with very little bodywork—only the bare essentials to test the mechanical resolve of the car.

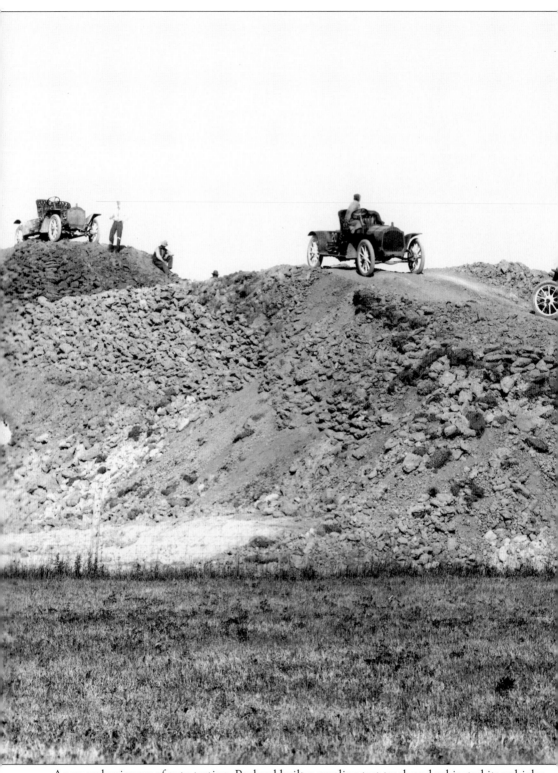

As an early pioneer of auto testing, Packard built a grueling test track and subjected its vehicles

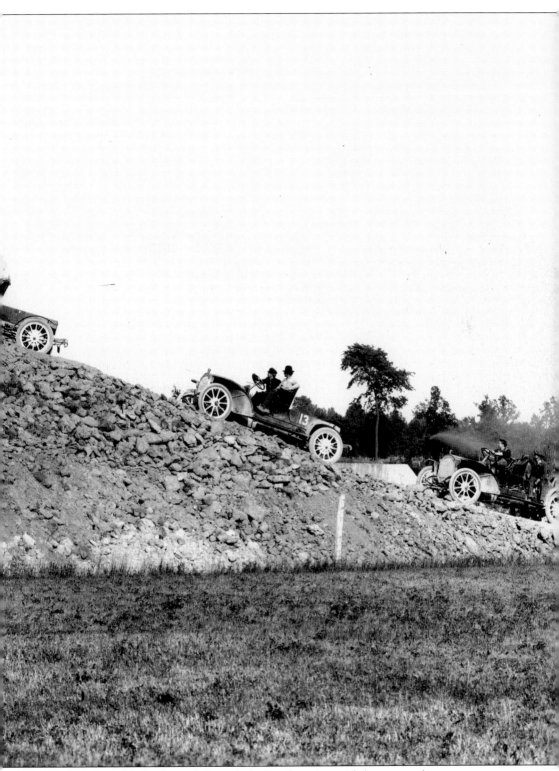

to demanding tests. Shown here is a steeply inclined section with loose gravel.

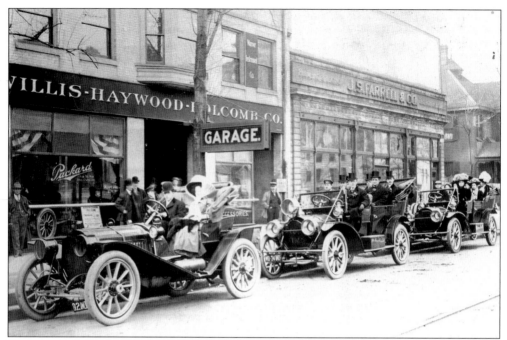

Well-dressed motorists pause in front of a Packard dealership in 1910. In the window is the Packard logo with the well-known slogan—"Ask the man who owns one"—that some say was developed in the first years of the company. *well when was it developed? In Ohio by J. Ward Packard! Fool.*

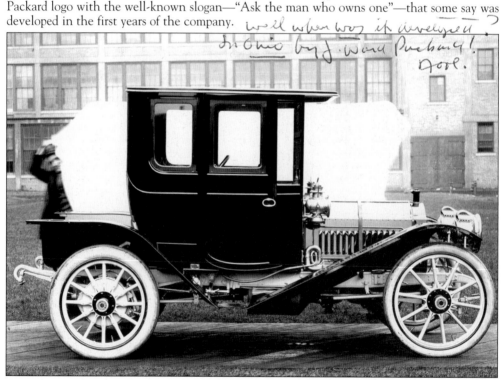

A newly completed Packard coupe is shown being photographed outside the factory. Workers hold up a sheet behind the car to act as a blank background. The photograph was later touched up by artists for use in the Packard catalog.

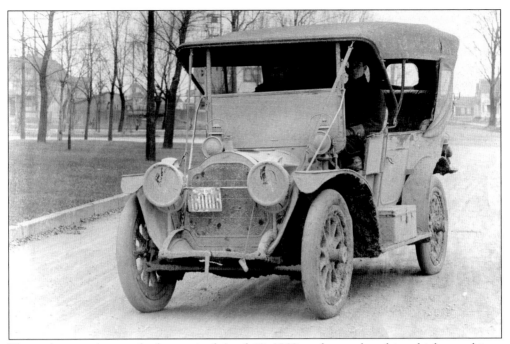

These photographs were both notarized April 13, 1909, and state that this vehicle was driven from Michigan over the mountains of Pennsylvania and back to Detroit between March 26 and April 9, 1909.

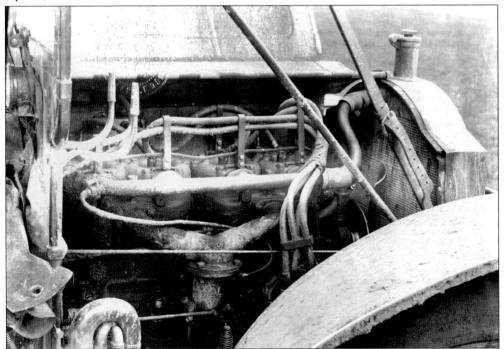

This photograph documents the engine's appearance following the long journey through the Pennsylvania mountains and back. This journey was likely undertaken by Packard-sponsored test drivers.

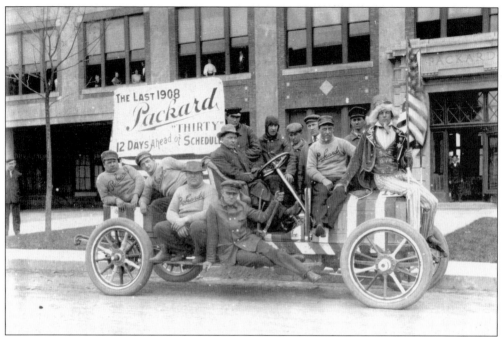

Packard employees pose in patriotic fashion in front of their factory. The sign shows that the last 1908 Packard "Thirty" is 12 days ahead of schedule. The workers are riding in a candy-striped Packard test vehicle.

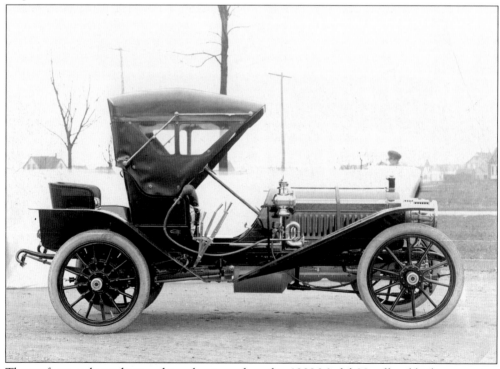

The roofs on early roadster and runabouts, such as this 1908 Model 30, offered little protection from anything but the sun.

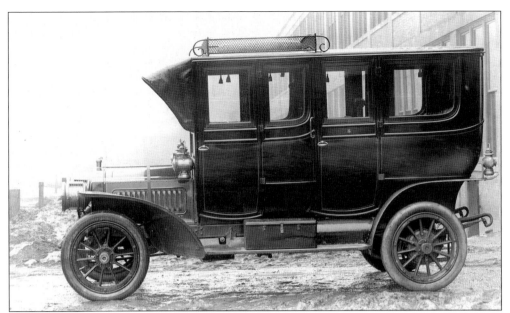

As opposed to standard limousines that were usually used around town, this mighty all-weather touring limousine from 1909 is equipped for long-distance driving. Fully enclosed bodywork, toolboxes, a roof rack, and large lamps suggest this vehicle was custom built for owners needing to travel long distances in a variety of weather conditions.

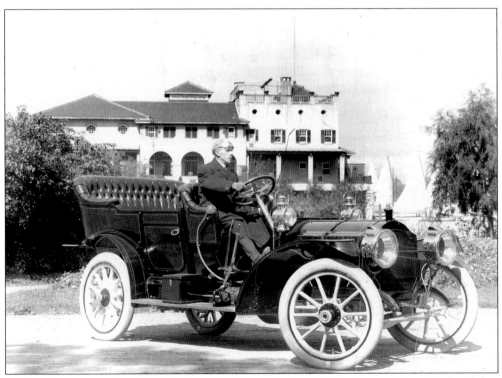

A chauffeur poses with a 1909 Packard touring car in front of the Grosse Pointe Yacht Club.

Maybe — it looks like the Boat Club. BWT
on this one I could be wrong. 6.X.06

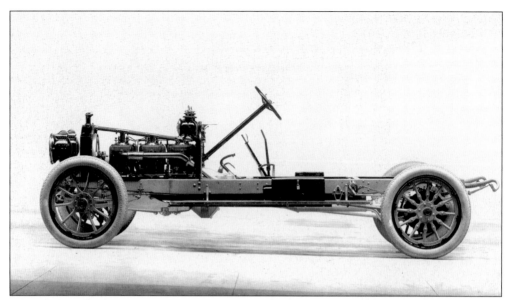

The 1911 Model 6 had the first six-cylinder engine offered by Packard. The 525-cubic-inch engine produced 74 horsepower and powered a 133-inch wheelbase chassis. This chassis could accept any body style, and the resulting car weighed over 4,000 pounds.

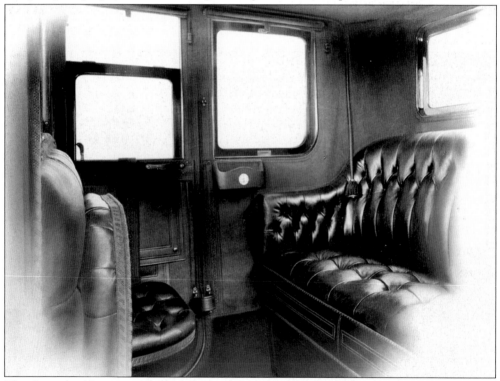

The elegant and luxurious leather interior of the 1911 Model 18 limousine was a departure from the usual broadcloth interior of other makers' enclosed cars. Leather was common on open cars as well as for the chauffeur's area of a limousine. The fringe-covered tube on the back seat was for one-way communication with the chauffeur.

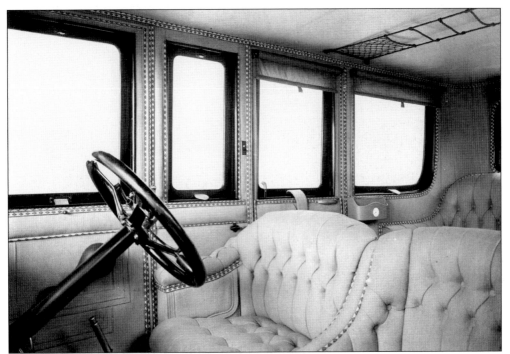

The patterned trim selected by the owner of this 1912 Model 30 brougham created a unique appearance.

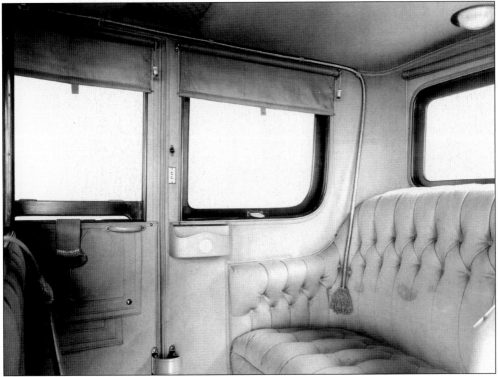

A 1912 Packard 6 brougham interior is shown in this photograph.

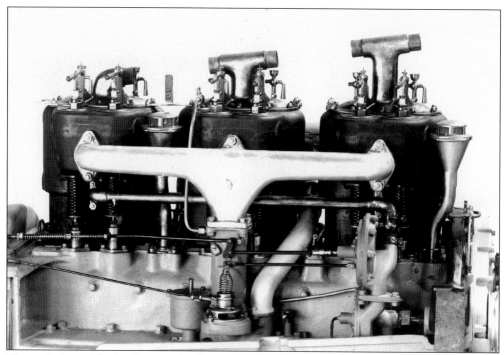

The cylinders of Packard's six-cylinder engine were cast in pairs and mounted to the engine block. The brass priming cups seen at the top of the heads were filled with gasoline to allow for direct priming of the engine when it was started.

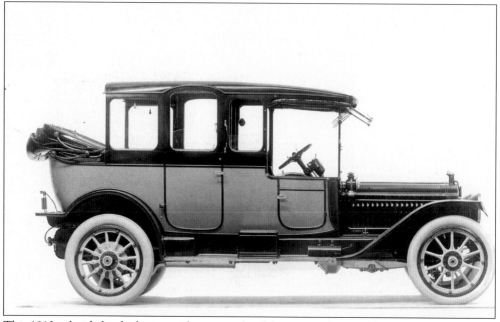

This 1913 cab side landaulet is another example of the tremendous number of variations on the limousine body. These cars were designed and specified by their owners and often comprised parts they liked about other vehicles they had seen. After such customizing, the end result could be an unusual combination.

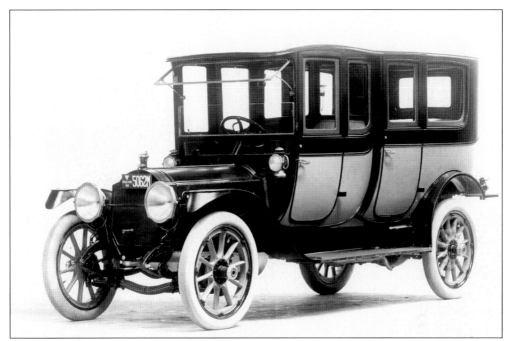

The body style of this 1913 Model 48 Imperial limousine looks a bit like the coupe with an extra body fitted to the back. Note the detailed pinstriping along the front axle and the Packard manufacturer's tag hanging from the radiator.

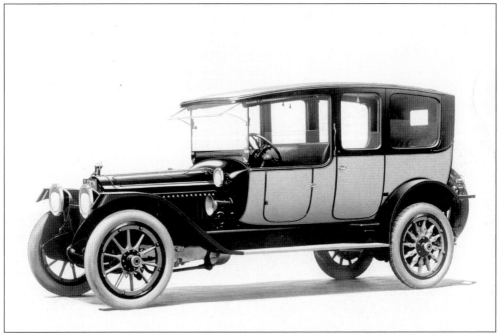

This 1914 Model 48 six-passenger landaulet, with its brougham-style body, offered plenty of headroom for its occupants so that no hat removal was required. Although not obvious in this view, the rear portion of the roof could be folded back, giving an open-air driving option for the passengers.

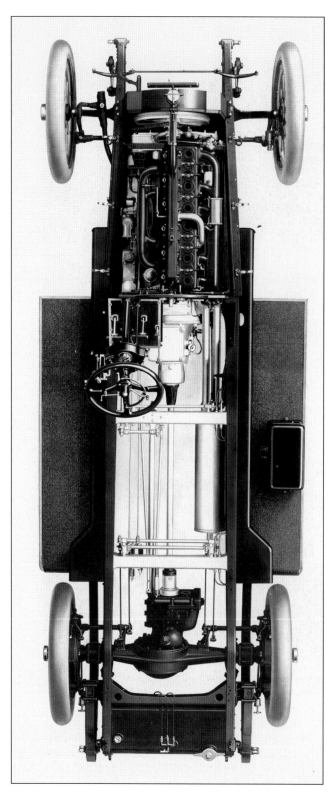

Model 3-38, the third revision of the Model 38, featured a 415-cubic-inch six-cylinder engine that developed 65 horsepower. The engine had many advanced and interesting features, including dual-magneto ignition, acetylene-primed carburetion, and an auxiliary oiling system that was interconnected with the throttle.

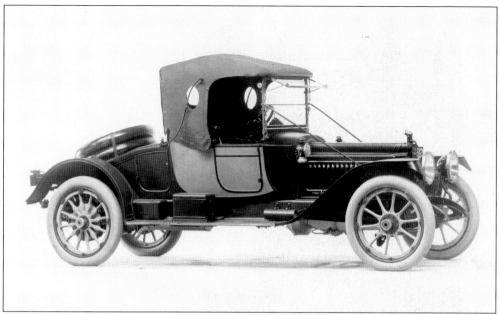

The Model 38 chassis fitted with a runabout body style weighed close to 4,000 pounds and, when built as a limousine, would add another 600 pounds. Depending on the body style, prices for the Model 38 ranged from $4,050 to $5,400.

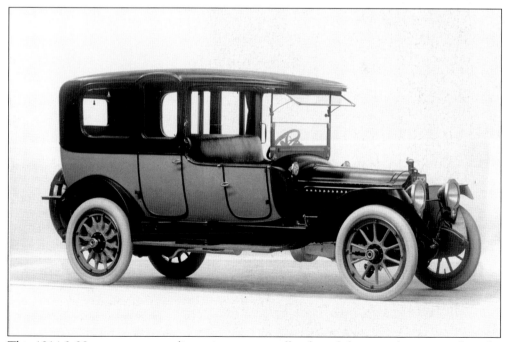

This 1914 3-38 seven-passenger limousine was not offered until the second revision, when the wheelbase was lengthened by six inches. The 3-38 was the first Packard to come standard with full electric lighting. The prior Model 38 had relied on a combination of electric tail and marker lights with acetylene headlamps.

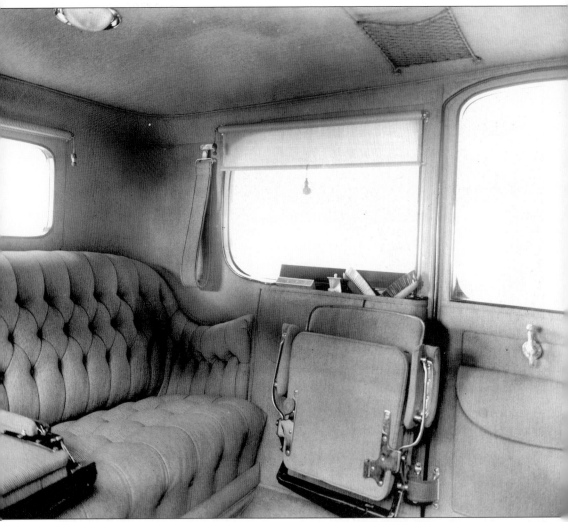

This interior view of a 3-38 limousine shows some of the luxurious items that were standard equipment. The silver-plated toilet items seen above the jump seat were available on all enclosed Model 38s, and the parcel carrier and folding footrest were also included. This model includes very elaborate folding jump seats that bring the seating capacity to seven.

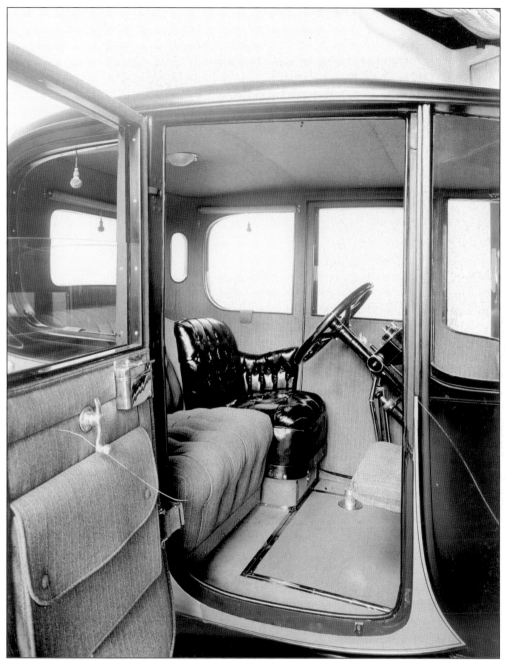

The 1914 3-38 coupe interior is a most unusual arrangement for a coupe, as is exemplified by the rear-facing jump seat. The driver's seat is covered in leather (indicating it was likely chauffeur driven), while the remaining seats are broadcloth. All of the interior brightwork on the Model 38 was silver plated.

Very similar to p. 69.

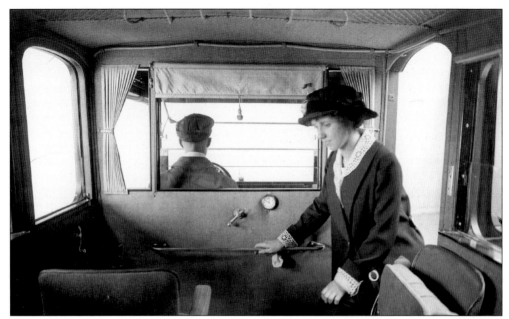

The Model 38 seven-passenger limo, shown in this forward-looking interior view, is spacious and well appointed. Fine curtains separate the passengers from the chauffeur, and an eight-day clock is mounted on the partition's wall. The elaborate jump seats were quite roomy and featured comfortable armrests.

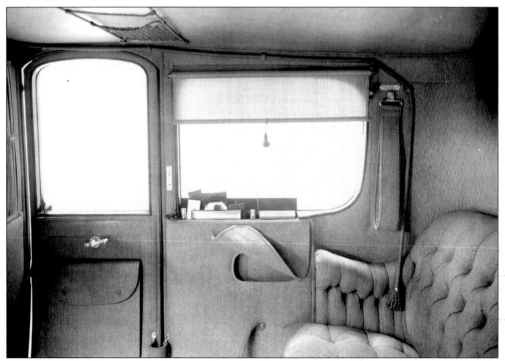

Another view of the same limousine shows the fringe-covered tube that was draped over the passenger seat; passengers used this tube for speaking to the chauffeur, although he could not speak back. These speaking tubes were standard equipment on all Model 38s with divisions.

Three
THE TWIN SIX

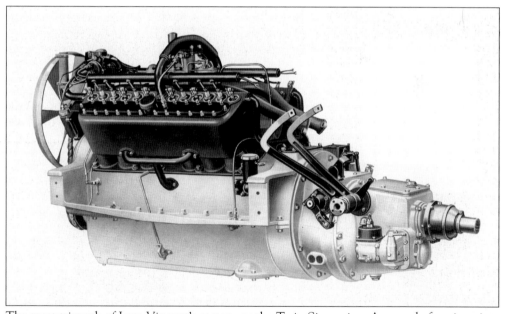

The great triumph of Jesse Vincent's career was the Twin Six engine. A marvel of engineering, this 12-cylinder engine was one of the first of the successful large V-engines. It set new standards for power, smoothness, and reliability. It displaced 424 cubic inches, was cast in two separate six-cylinder blocks, and developed 88 horsepower. The technical triumph of the Twin Six inspired Enzo Ferrari to produce his own 12-cylinder engines.

Well Ready! There were many others. It was Bugatti who loved Pinhards.

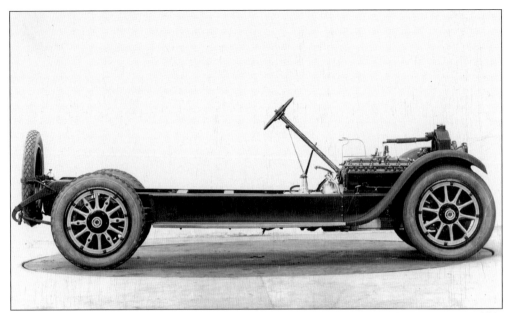

A side view of the Twin Six chassis shows how the construction of this chassis was incredibly robust. The frame rails were six inches deep and were heavily reinforced with cross bracing. The wheelbase was 125 inches, and weights started at around 4,000 pounds.

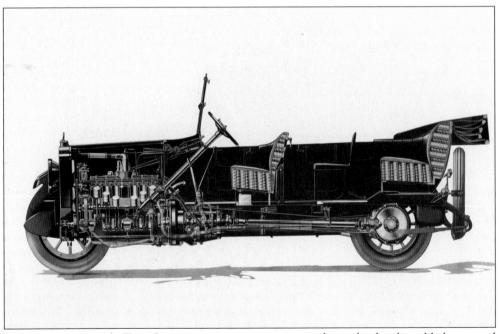

This cutaway view of a Twin Six seven-passenger touring car shows the deeply padded seats and generous rear legroom. Such illustrations were used in Packard's sales brochures.

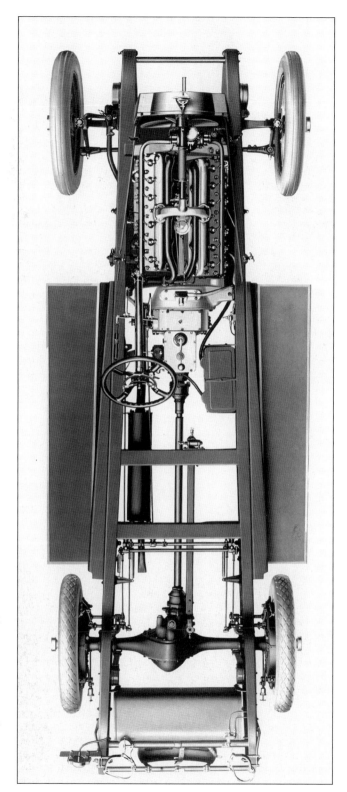

This view shows the Twin Six chassis—a simple but very strong arrangement. The brakes were mounted on the rear wheels only and would stay that way for a few more years. Early brakes were not considered predictable enough to be mounted to the front wheels, where any inconsistent force would create steering problems.

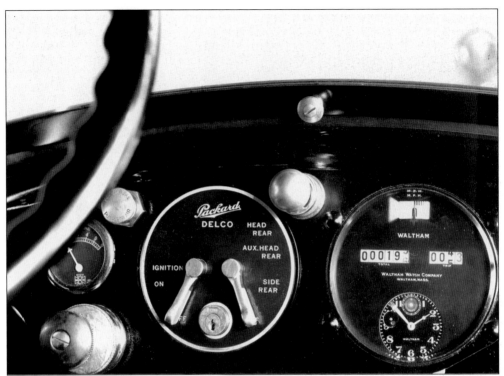

The dashboard of the Packard Twin Six shows the ignition switch area with light switches. This arrangement was short lived on Packards but was used for decades by Rolls-Royce. The speedometer is made by the clockmaker Waltham and features an attractive clock.

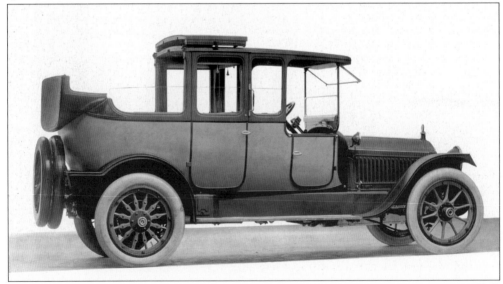

This 1916 Twin Six landaulet is a fine example of the cars the Twin Six engine propelled. Primarily large touring limousines, these were very heavy and benefited from the extra power of the 12-cylinder engine. This car has an unusual landau roof that has a semirigid structure and folds backward. The rigid roof section, which slides forward, is also uncommon but makes for a weatherproof arrangement when fitted in place.

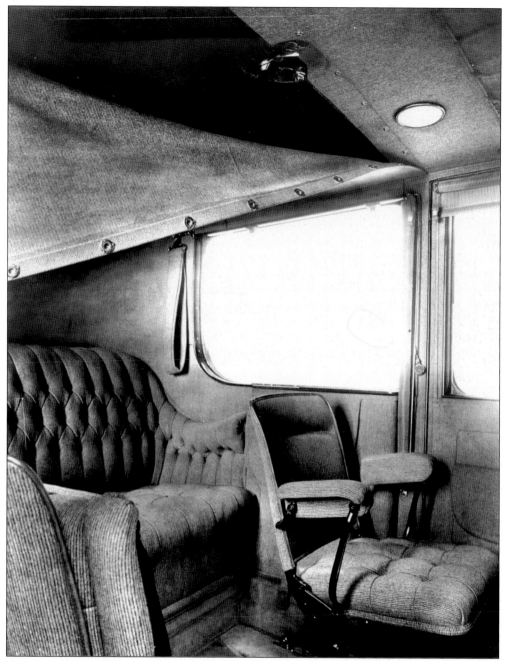

The detached headliner on this jump-seat-equipped Twin Six brougham indicates that it has some sort of landau top or removable roof section.

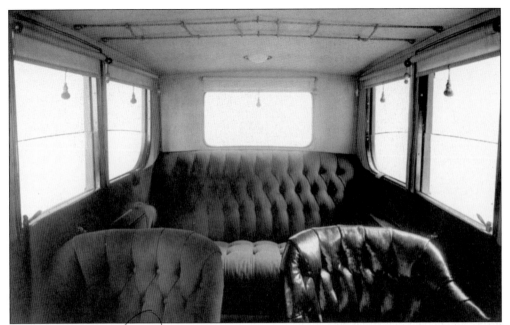

This interior shot of a 1915 Twin Six brougham shows a smaller five-passenger enclosed body that was still designed to be driven by a chauffeur, due to the leather covering only on the front seats. Leather was used only for the passenger seating on open cars and at this time was considered less luxurious than fine broadcloth.

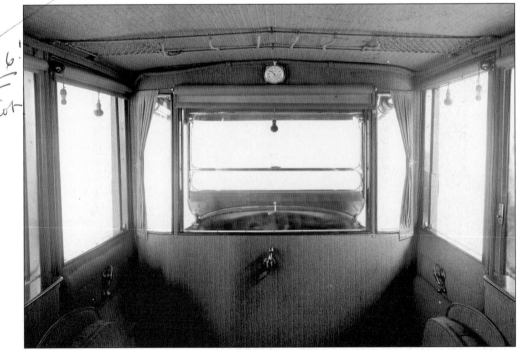

A forward-facing view of the spacious interior of the Twin Six limousine is the view the passengers would have been most familiar with. Note the dual electric dome lights and center-mounted eight-day clock. The straps on the ceiling could be used to carefully store hats.

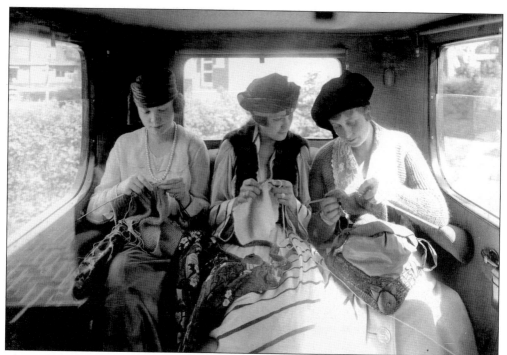

These elegant women are comfortably knitting in the back of their Twin Six limousine. The photograph nicely illustrates the spacious and bright seating area of the Twin Six.

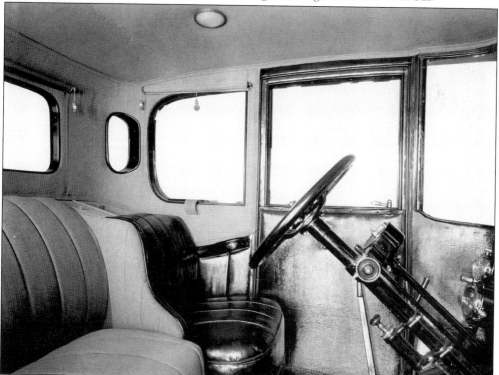

Shown is an interior view of a three-passenger Twin Six coupe.

Is this a Twin Six? I doubt it (see p. 61)

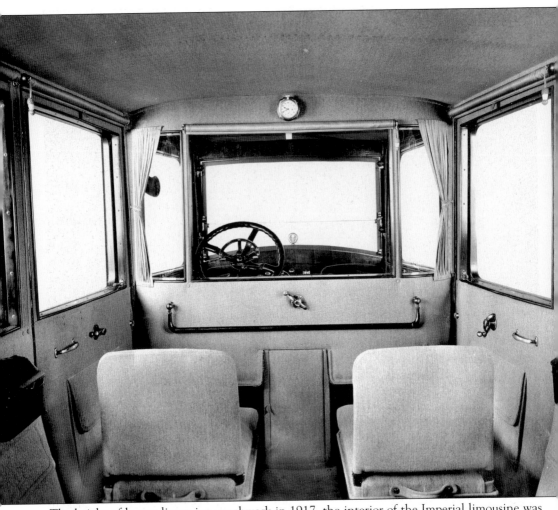

The height of luxury limousine coachwork in 1917, the interior of the Imperial limousine was
more like an elegant train coach than an automobile.

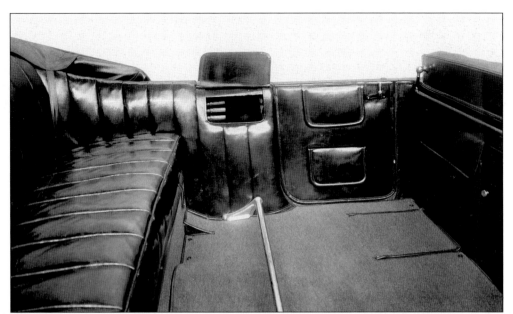

The passenger area of the seven-passenger touring car featured jump seats that could be folded forward, leaving tremendous legroom for the occupants. The bar on the floor is a footrest, and the rail behind the front seat is for storing lap robes—standard equipment for open-car touring.

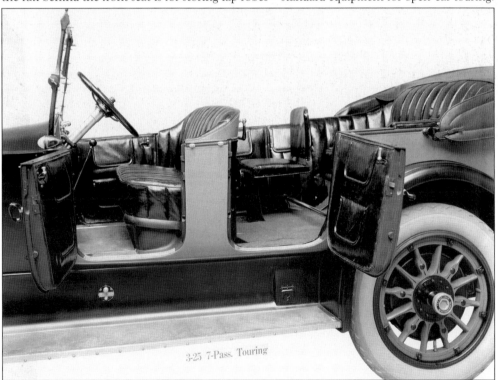

3-25 7-Pass. Touring

Open Packards, such as this Model 3-25 seven-passenger Twin Six touring car, were almost always equipped with leather seating in the front and rear. Leather was more durable and resisted the elements better than broadcloth but was not considered as luxurious.

This is the only correct statement in the book!

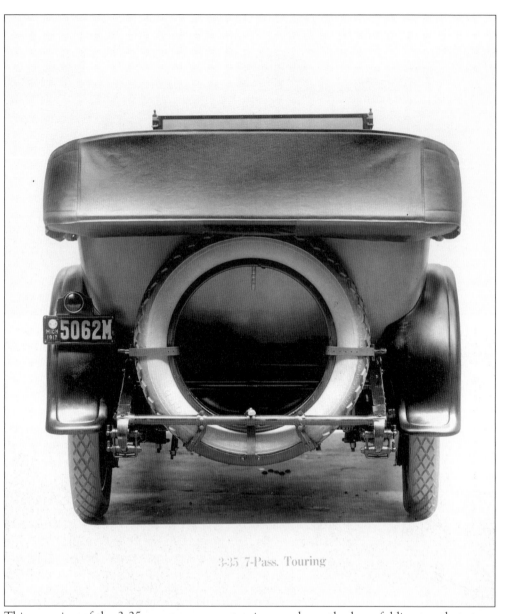

3-35 7-Pass. Touring

This rear view of the 3-25 seven-passenger touring car shows the large folding top that stores neatly under the fitted cover.

Four
POSTWAR

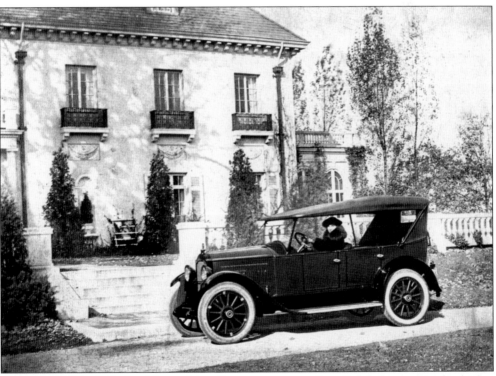

After World War I, Packard focused its efforts on some smaller, slightly lower-priced vehicles. The first to emerge was the Model 116 with its powerful but less complex six-cylinder engine mounted to a shortened chassis. These cars were intended to be driven by their owners rather than chauffeurs, as the trend was shifting toward wealthy owners driving their own vehicles. More women were also interested in driving, and Packard began featuring more and more women at the steering wheels of its cars.

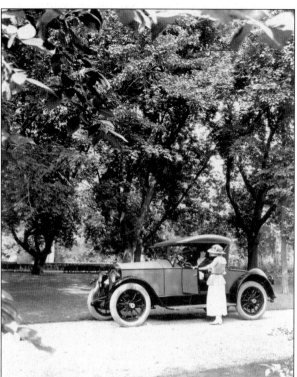

This smaller Model 116 Single Six runabout model was clearly being targeted toward women drivers with this publicity photograph.

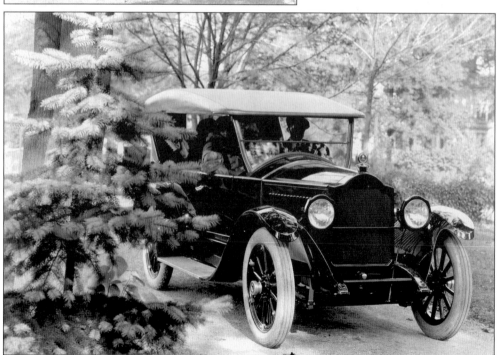

With almost all the metalwork having been painted, this Single Six Model 116 lacks the exterior brightwork of prior Brass Era models. Changes such as this were made in an effort to keep the price down on this new, smaller Packard.

But it wasn't new – it had more to do with design and extending the hood.

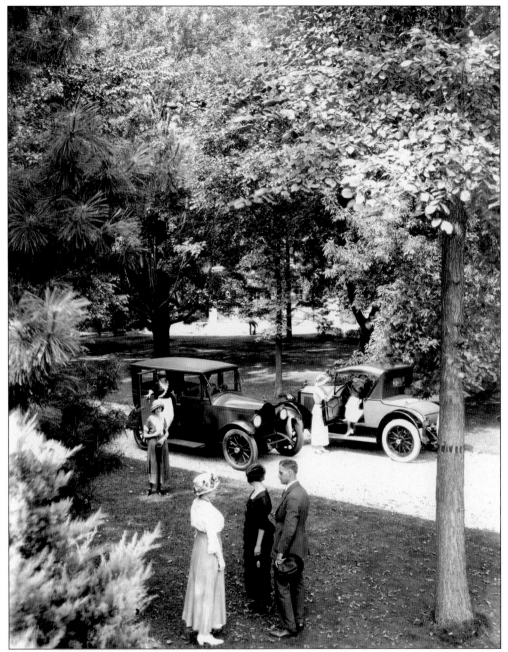

A staged photograph of a roadster and sedan meeting in a park shows well-dressed drivers who reflected Packard's dignified, upper-class customers.

Belle Isle?

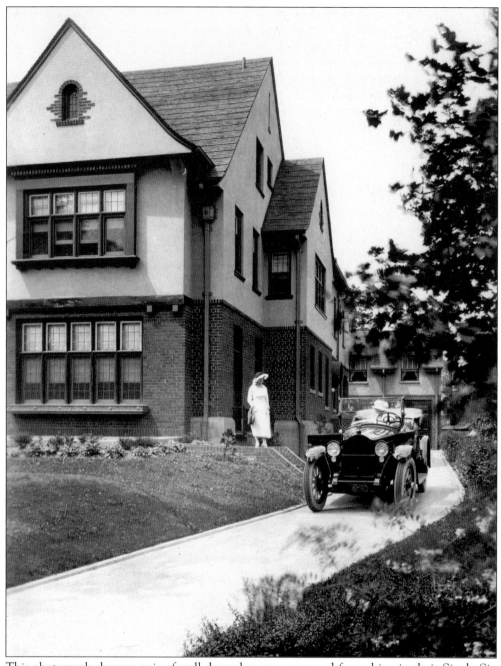
This photograph shows a pair of well-dressed women prepared for a drive in their Single Six touring car.

A Single Six sedan is shown parked by the gardens.

Packard continuously tested its vehicles in all sorts of conditions, as seen here. The chains shown on the rear wheels of this Single Six climbing a snow-covered grade were mandatory equipment in the early days of winter motoring, as the thin tires offered little traction by themselves.

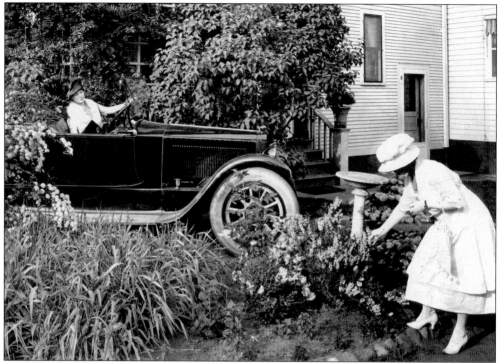

A woman is shown here driving her Twin Six touring car.

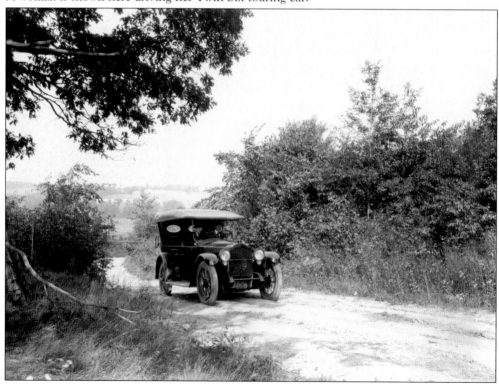

This photograph shows a 1920 Twin Six tourer navigating a rough country road.

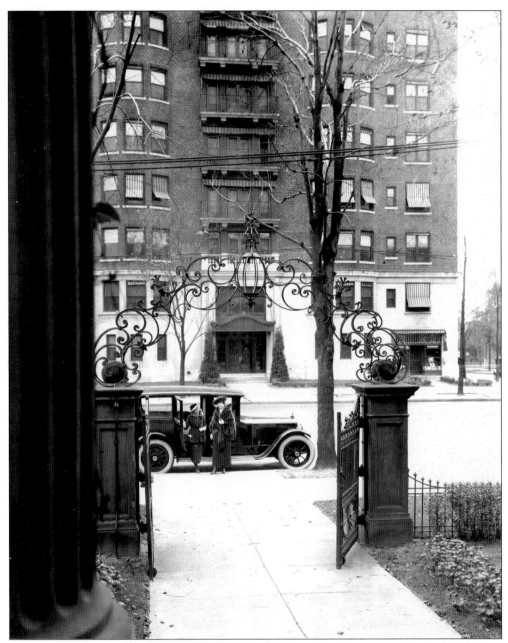

Two elegant women arrive at the gates of a home in their chauffeur-driven Twin Six limousine. Packard's advertising carefully illustrated the lifestyle of wealth and good taste that they were associated with.

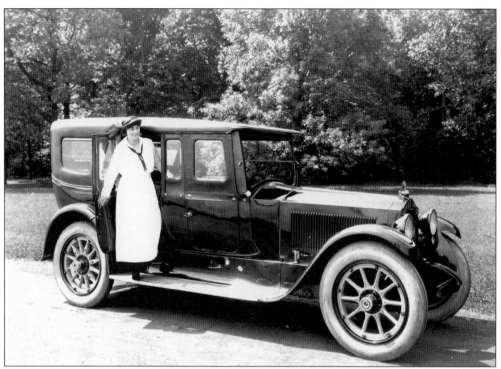

This 1920 Twin Six tourer is shown fitted with an Art Craft hardtop.

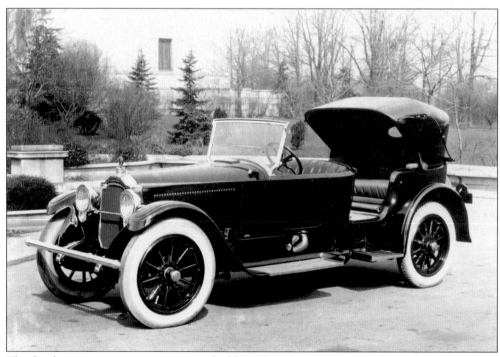

The doorless passenger compartment and odd coachwork on this eye-catching Victoria are quite peculiar. Buyers could specify nearly any type of modifications they wanted for their vehicles.

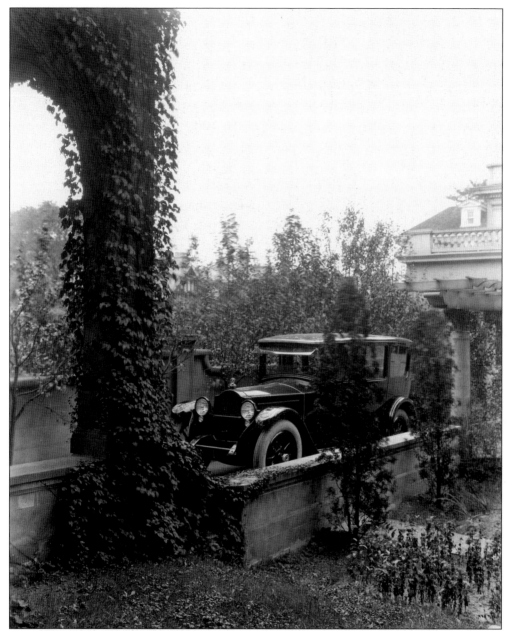

A 1920 Twin Six limousine is shown parked in some luxurious off-street parking.

It's on an estate in Grosse Pointe. fool.

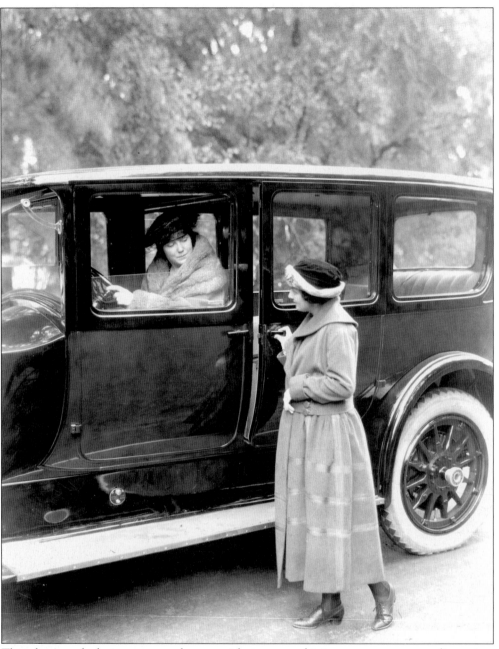

This photograph shows an unusual scene with a woman driving a seven-passenger limousine. Even in those days, such vehicles were not intended to be owner driven, and it was often considered to be in bad taste to be seen driving your own limousine.

yes – and they certainly are cute.

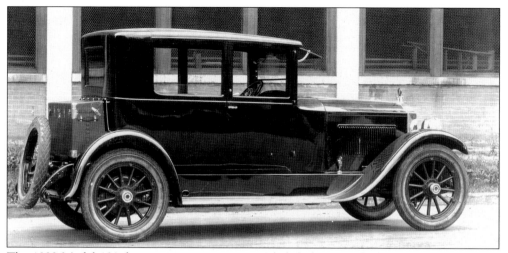

The 1922 Model 133 five-passenger coupe was a slightly larger and more powerful version of the Single Six. This model number indicated the length of the car's wheelbase in inches.

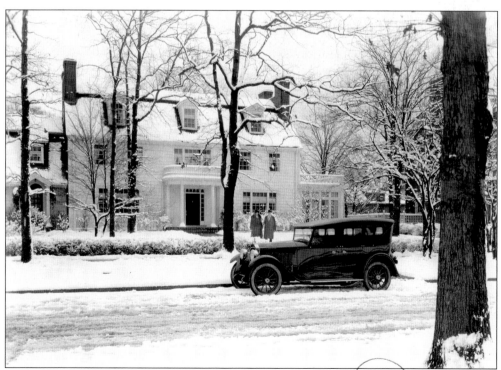

The Model 126 touring car, shown here in a winter scene, was a straight six with a 126-inch wheelbase. The touring car is fitted with all its side curtains for cold-weather protection.

of course it was a straight 6 — there was no other kind until the 1960's. Idiot.

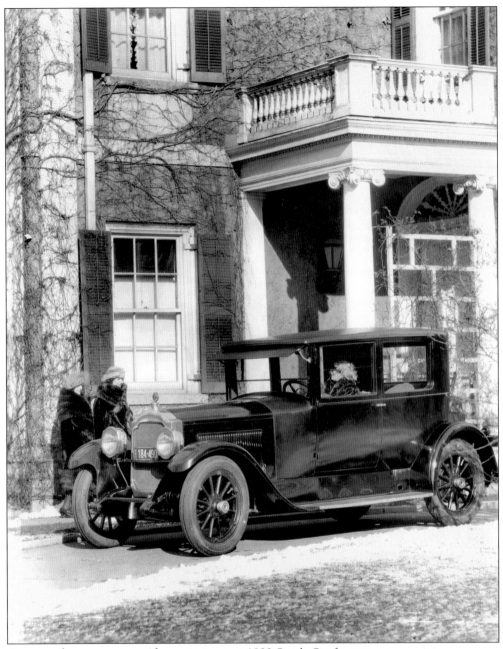

A group of women prepares for motoring in a 1922 Single Six five-passenger coupe.

Looks like the War Memorial.

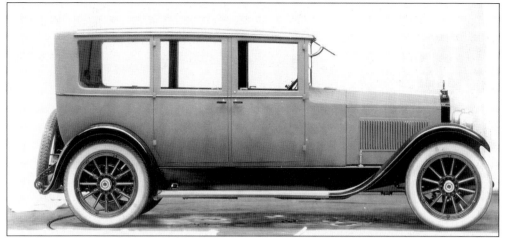

A conventional Single Six 126 sedan is shown here in a side view.

Lovely coherence design.

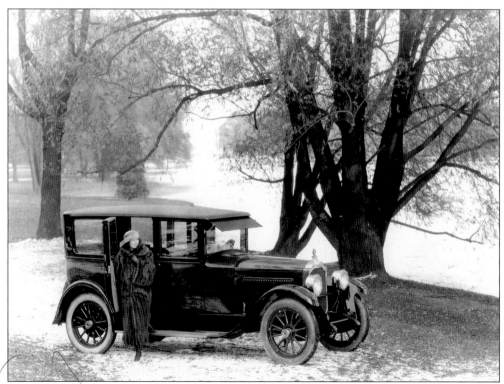

A very shiny 1922 133 Single Six is photographed at a lakeside setting.

They all were. Hand rubbing (w/ glass paper

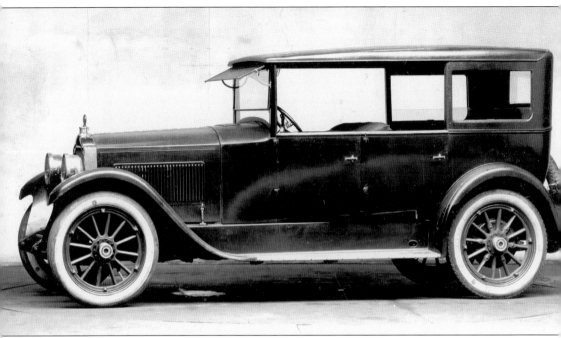

Consumers could choose from an incredible number of body variations. This unusual body style is a five-passenger touring sedan with a fixed top and rear side windows. The open sides required that side curtains be installed when protection from the weather was needed.

Surely this was a custom – not a standard factory body.

Five

THE CLASSIC ERA

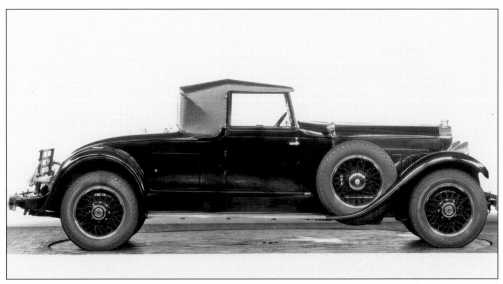

In the late 1920s, Packard produced some of its most elegant and influential vehicles. Long and handsome, these are the vehicles most associated with the Packard brand. This car is a 1928 Model 645 convertible coupe made by Dietrich, Packard's most famous and perhaps most desirable custom coachbuilder. Dietrich produced some wonderfully elegant bodies and are some of the most desirable Packards to collect today. *I well yes. This at least is correct.*

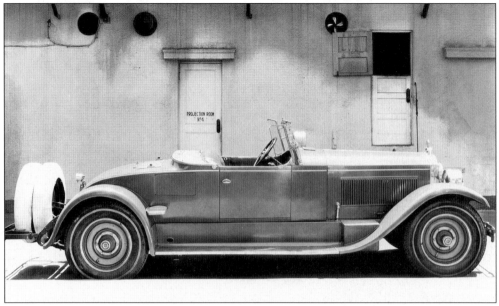

A 1927 roadster is shown equipped with the disc wheels that most people associate with the classic era of the Packard marque.

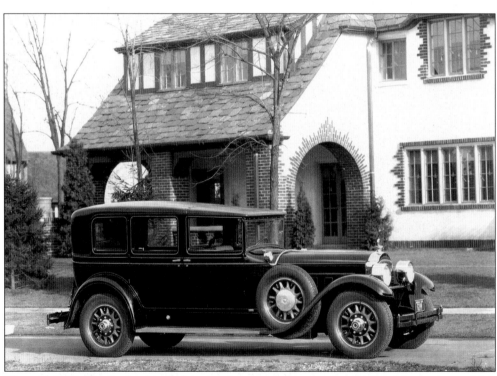

The mid-1920s saw Packard introduce its phenomenally smooth straight-eight engines, which had ample power in a design that was robust but simple. The twelve, eight, and super-eight chassis were fantastic platforms on which to have custom bodies built. Packard used several of America's best coachbuilders, including Dietrich, who produced this handsome town car.

1924 in fact. These designations did not appear until 1935 or 1936.

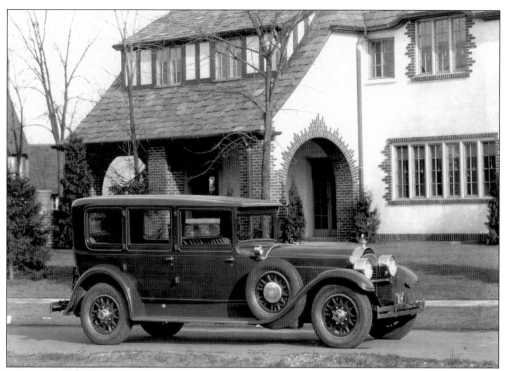

The coachbuilder Holbrook produced this sedan limousine for Packard.

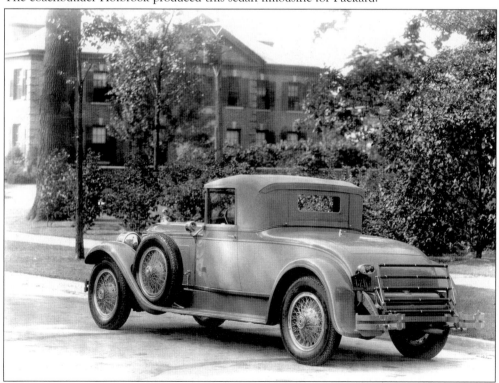

This photograph shows a 1927 two-passenger convertible coupe. *no – 2/4 – there was a rumble seat. Idiot.*

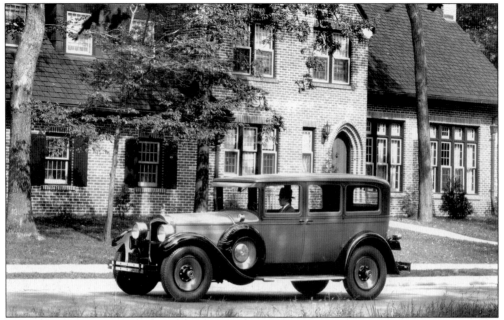

Despite the simple appearance of the painted disc wheels shown on this 1927 Packard Sedan Deluxe, such wheels were the most expensive wheel option available. At this point, artillery, wire-spoke, and disc wheels were all available. Discs were quite fashionable in the 1920s and therefore had the highest price tag.

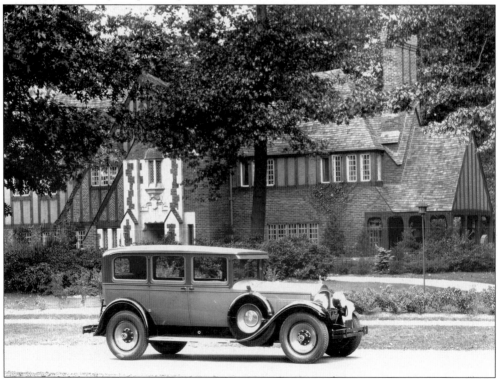

The same Sedan Deluxe is pictured from another angle.

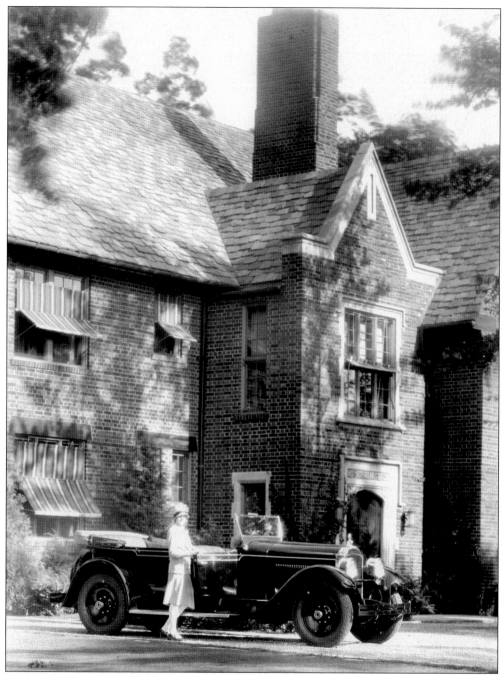

A woman dressed in the height of 1920s fashion gets into a 1927 Model 533 Phaeton. "Phaeton" and "touring car" were often interchangeable terms for open American cars that could carry four or more passengers. Packard offered models using both terms, the phaeton being one with a lower windshield and top, but a slightly higher price.

no. Phaetons had roll-ups windows

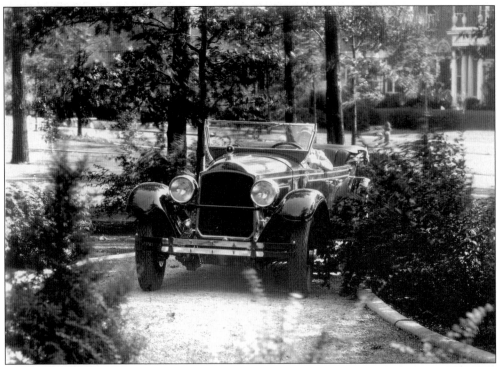

A front view of the Model 533 Phaeton is shown in this photograph.

Although less formal, the rear-mounted spare shown in this side view of a 1927 five-passenger sedan gave the car cleaner lines.

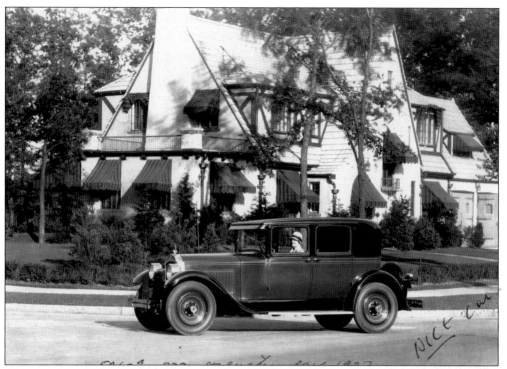

This photograph shows the 1927 five-passenger club sedan.

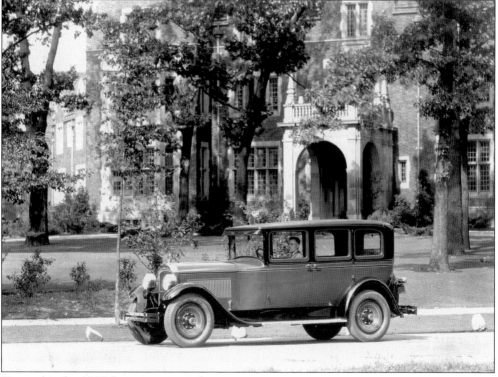

Pictured is the 1927 five-passenger sedan.

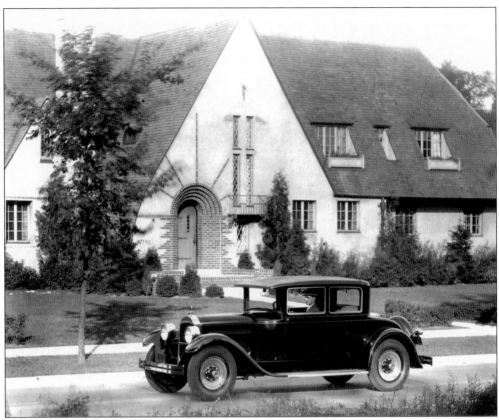

Shown here is a 1927 four-passenger coupe.

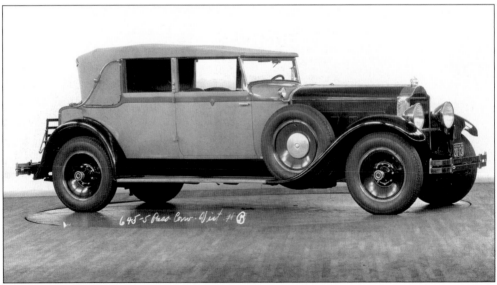

A Model 645 five-passenger convertible is shown with the top up. This car, like many others, was photographed on a turntable at the Packard factory that allowed for photographing a car from many angles without moving the camera.

Same car on p. 97 — misnamed

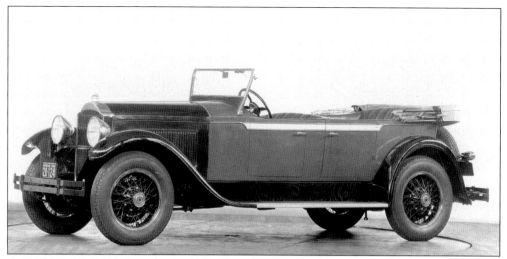

A 1928 Model 633 five-passenger phaeton with an unusual multitone paint scheme is shown with the top down.

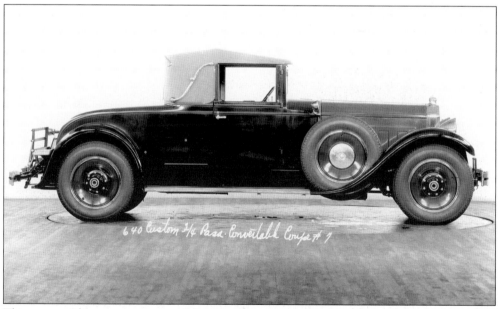

This custom 2/4 passenger convertible coupe shows an amazing contrast between the length of the chassis and the size of the passenger compartment. This layout put style far ahead of practicality but makes for a very striking vehicle.

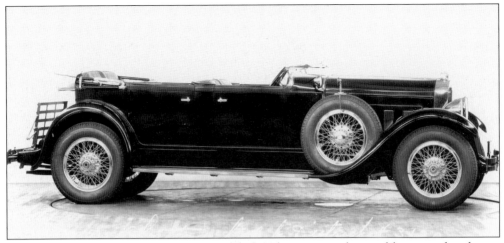

The Dietrich coachwork on this 1928 Model 645 Phaeton is understated but quite handsome. Many such phaetons were equipped with windshields that would fold flat for true open-air driving.

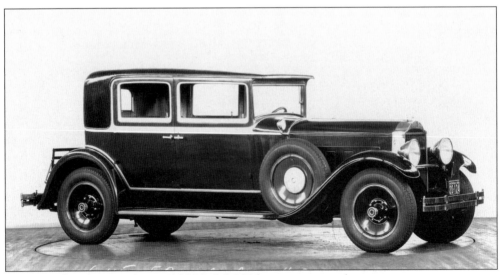

Shown in this photograph is a 1928 Model 645 five-passenger sedan.

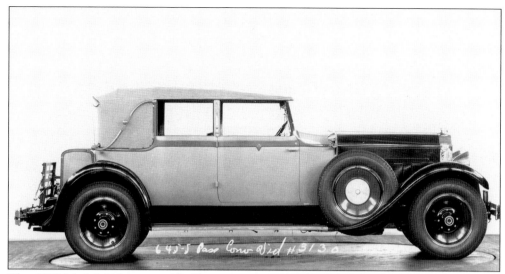

The 1928 Model 645 convertible Victoria was one of the most elegant body styles used by Packard. The convertible Victoria offered the pleasures of a convertible but the privacy of a sedan.

Except that this is not a Victoria! Despite the regained it is a 7 door conv. Sedan.

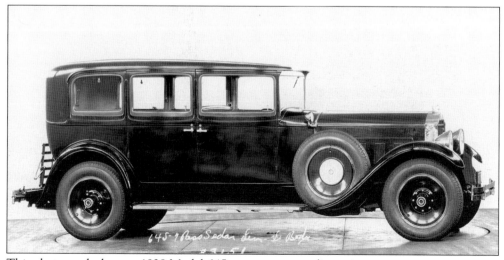

This photograph shows a 1928 Model 645 seven-passenger limousine.

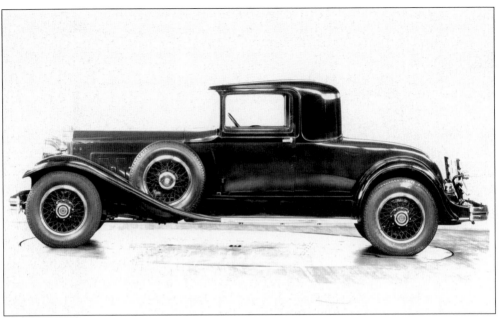

Shown in this photograph is a 1929 Model 745 coupe, a fixed-top version of the popular roadster.

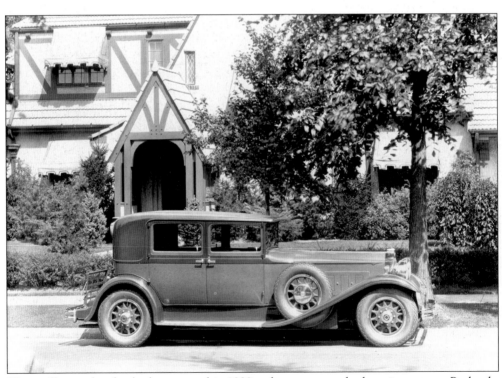

The artillery-style wheels shown on this 1929 sedan were standard equipment on Packards, although they were usually upgraded to wire spokes or discs.

no! Disc wheels were standard - artillery & wire wheels were options.

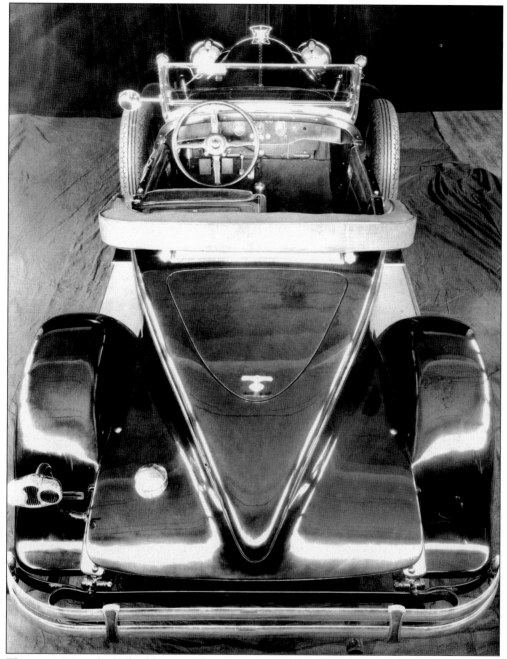

The incorporated trunk shown in this rear view of the boat tail speedster is particularly interesting in a time when most cars still used external trunks.

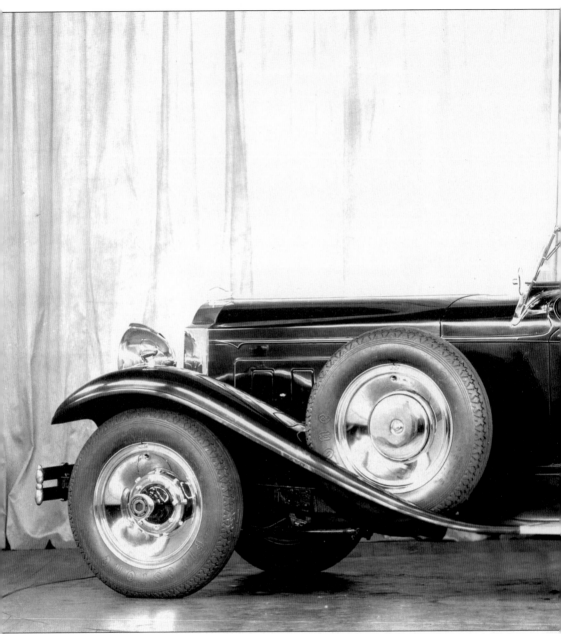

The boat-tail rear end and chrome disc wheels of this 1929 Speedster create a sporty and dramatic

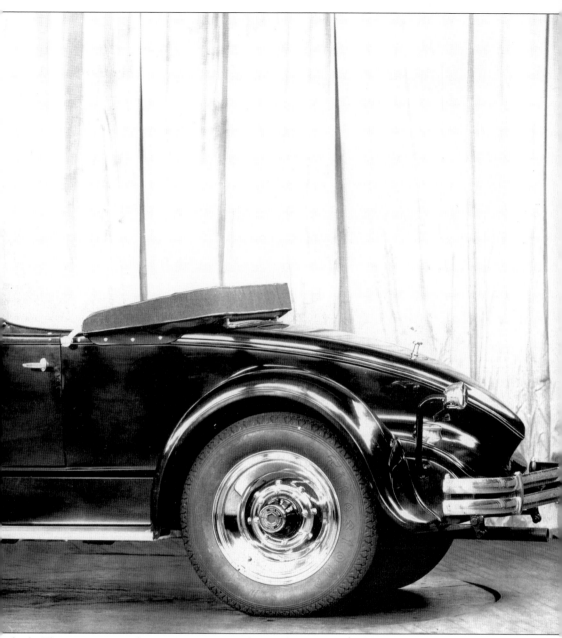

look. This was a rare and expensive car in its day, and it is now a highly desirable vehicle.

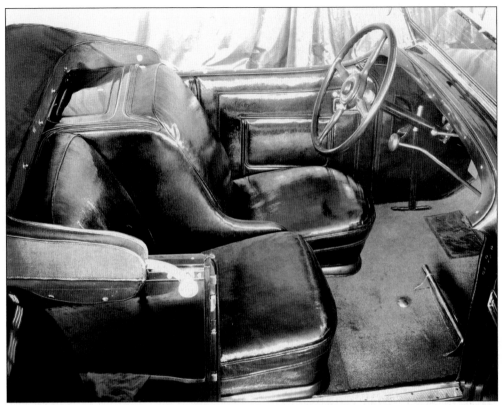

The interior of this 1929 Speedster differs from the standard roadster in that the passenger seat is mounted farther back, thus creating much more legroom.

not the point! The body was narrow. Staggered seats allowed more shoulder room. That's all.

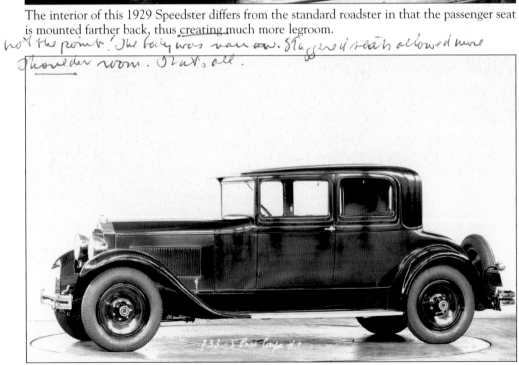

This photograph shows a 1929 Model 733 five-passenger coupe.

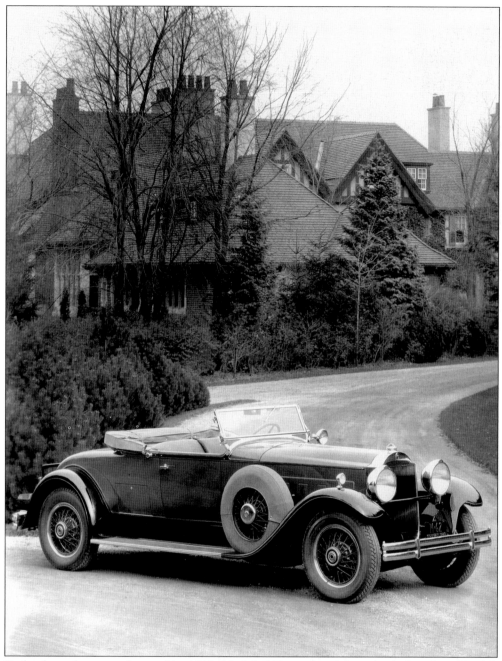

Packard roadsters, such as this 1929 Model 740, were often equipped with golf club compartments below the folded top.

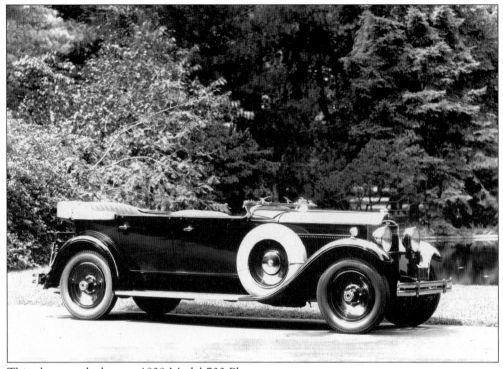

This photograph shows a 1929 Model 733 Phaeton.

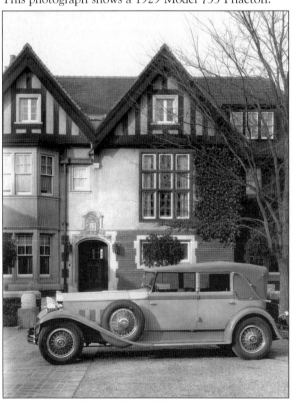

A 1929 Model 740 convertible sedan is pictured in front of the type of house befitting the car's owner.

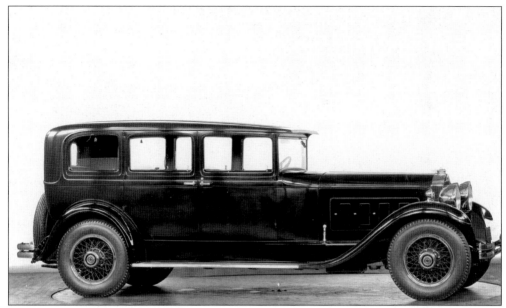

The massive Model 740 seven-passenger sedan was a formal, long-wheelbase sedan—ideal for transporting a wealthy industrialist to work. This type of vehicle was at its height of popularity just prior to the Great Depression, after which the demand fell off dramatically.

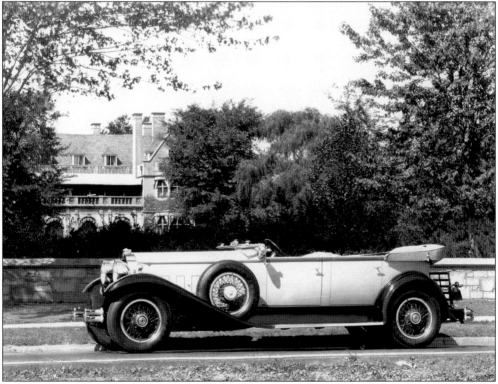

This 1929 Model 745 Phaeton is shown with its windshield folded forward. The Packard phaetons had fully folding windscreens for true open-air driving.

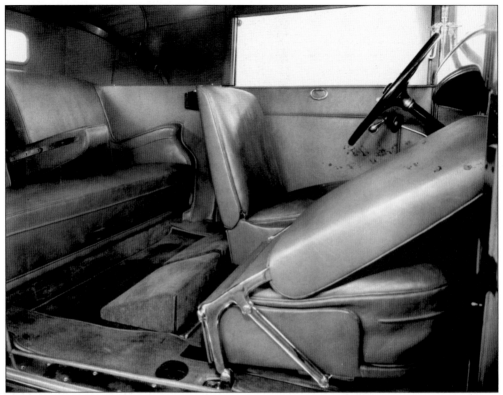

The interior of a five-passenger convertible by Dietrich features folding bucket seats for easy access to the rear seating area and footrest triangular blocks.

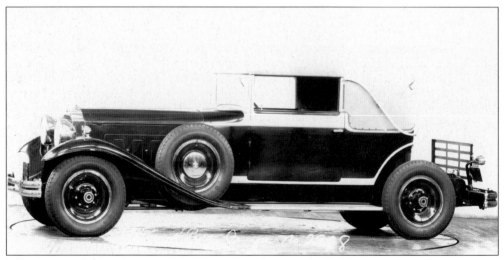

This 1929 Model 745 four-passenger coupe was photographed with its trunk missing.

This photograph shows a handsome 1929 Model 745 town car with coachwork by Brewster. Brewster was one of America's most respected coachbuilders and was best known for the bodies it produced for American-made Rolls-Royces.

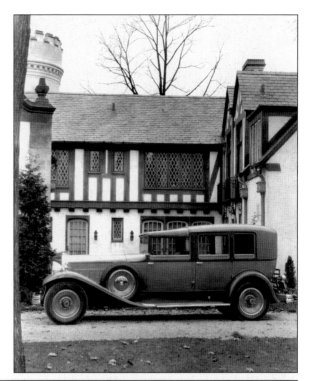

The interior of the Brewster-built sedan limousine features a finely appointed interior and other unique, owner-specified features, such as the folding leg rests shown in this model.

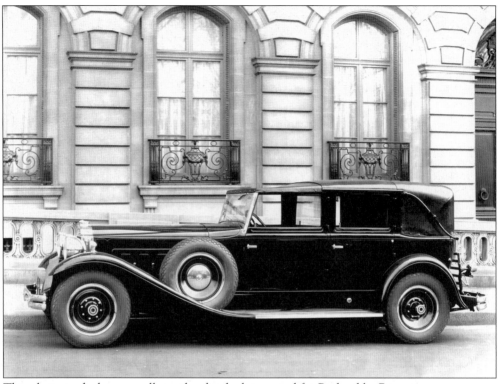

This photograph shows an all-weather landaulet created for Packard by Brewster.

This interior of a convertible sedan by Brewster features exotic, highly textured leather upholstery.

108 *There was nothing "exotic" about it – pressed top grain cow hide.*

These two photographs show the subtle differences between two custom coach-built interiors—a Rollston town car and a LeBaron all-weather landaulet.

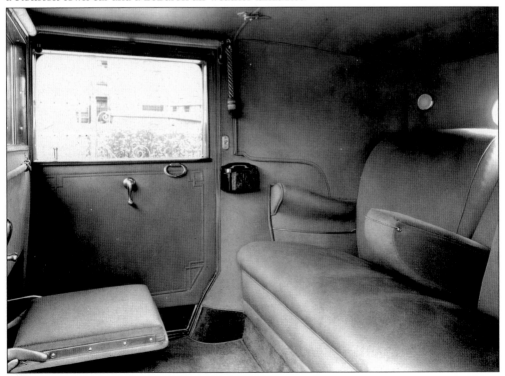

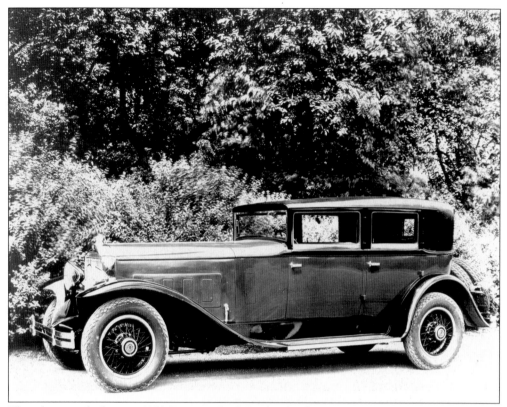

This photograph shows a 1930 Brewster-built Packard sedan.

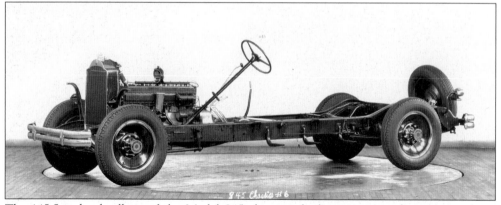

The 145.5-inch wheelbase of the Model 845 chassis is built to receive a limousine or large touring car body. The construction is incredibly robust, unlike anything built today.

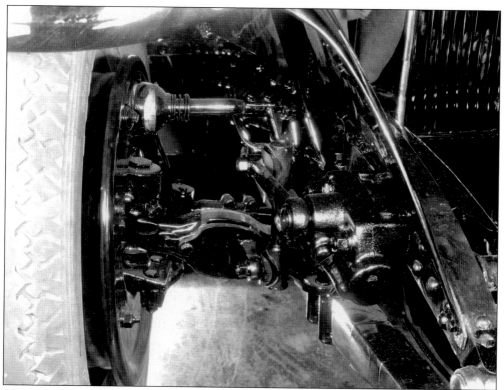

These photographs show the details of the 8 series chassis.

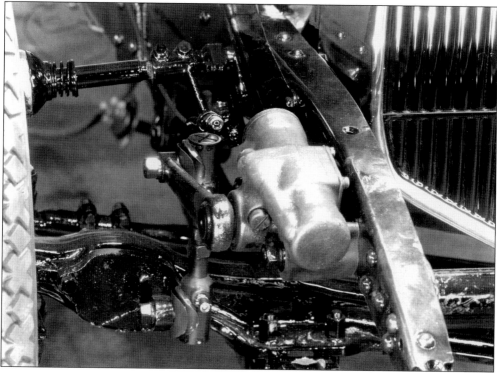

The optional disc wheels from a Model 845 chassis are shown in this photograph.

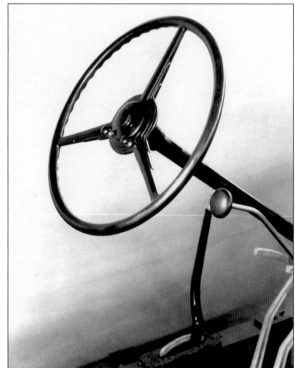

The steering wheel from an 8 series Packard contained an additional throttle control as well as controls for the headlights.

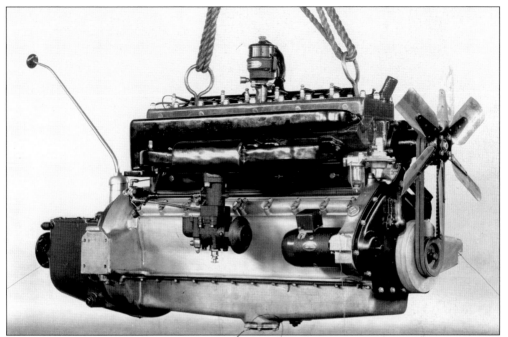

The straight-eight engine for the 1930 Model 840 displaces 384 cubic inches and develops 145-horsepower. These Packard straight engines are incredibly smooth and quiet, which was at least as important as power at the time.

*can he count? 1930 was the 7th series
1931 8th
1932 9th
etc.*

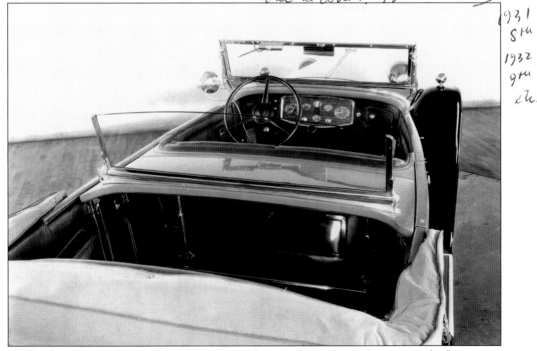

An overhead view of a 1931 Model 933 Sport Phaeton shows the dual screens and a flip-up rear tonneau cover. This design was popular with women who wanted to preserve their hairstyles while motoring and those who wanted additional privacy from the chauffeur.

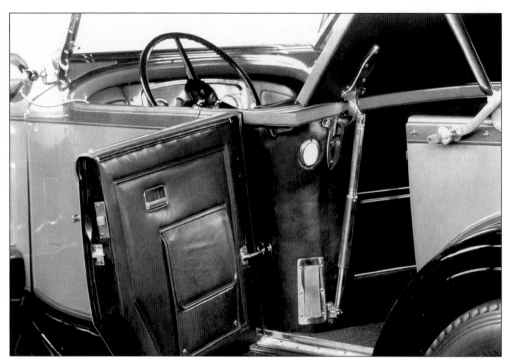

This photograph of the Model 933 Sport Phaeton shows the lifting action of the tonneau cover, the large spring cylinders, and the elaborate, substantial hardware that assisted in the lifting.

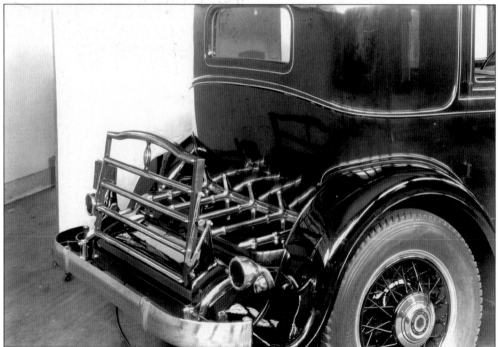

This 1931 Model 933 sedan is equipped with a truly elegant trunk rack. Its design mimics the trademark Packard radiator shape. Items like this rack were made from steel and then painted to resemble wood.

114 No. The luggage rack was never painted to do this.
It was painted the body color.

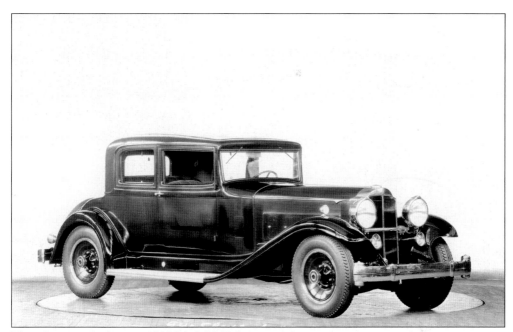

This photograph shows a 1931 Model 940 five-passenger coupe.

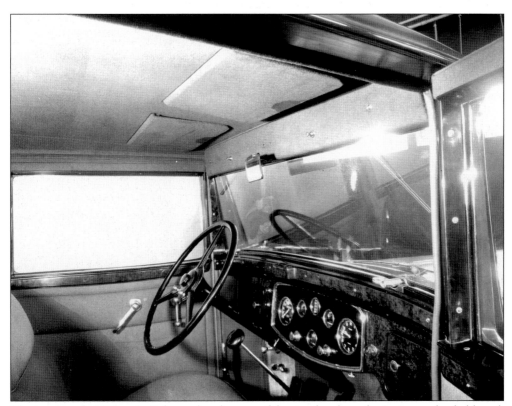

The interior of a 1931 series 9 shows abundant use of the simulated wood painting on the dashboard.

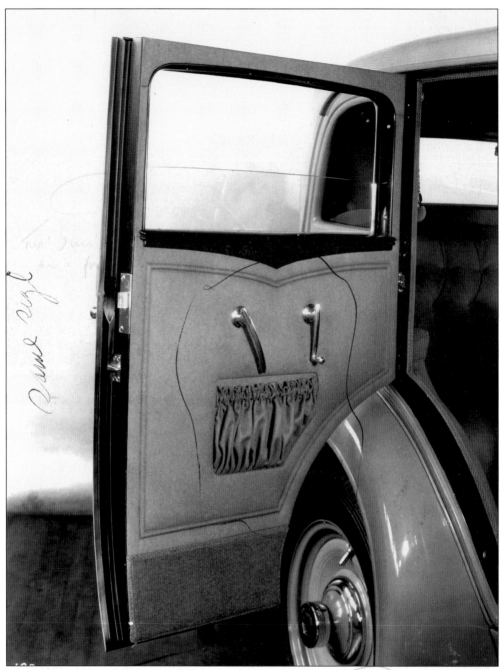

The interior door panel to a 1932 Packard shows styling that is simple but very elegant. Although once commonplace, doors like these that open at their forward edge are now referred to as suicide doors. If these doors were ever opened with the car in motion, the wind force would catch them and violently throw them open.

No! The door is hinged on its rear edge. That is why it opens backward and exposes the forward edge to the wind. This again is a 900 sedan.

116

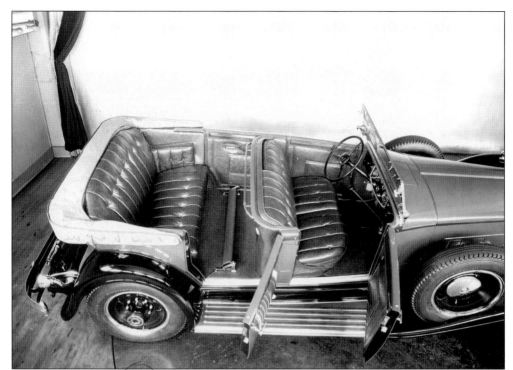

This view of a Model 940 Phaeton shows another example of the almost unlimited upholstery options available to customers. *no. 904 – There was no 940.*

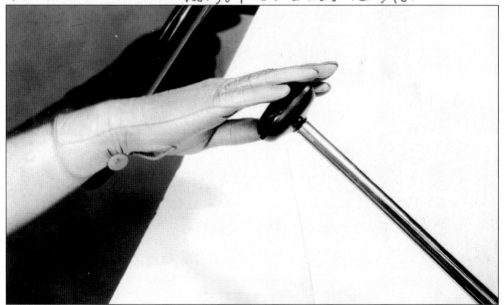

A curious factory photograph shows a woman's elegantly gloved hand reaching for the shift lever. This photograph illustrates the effortless nature of Packard's refined transmission, suggesting that gear changes could be made quickly and smoothly with barely a touch of the fingers. In reality, prior to the introduction of the synchronized gearboxes in the late 1930s, even the Packard transmissions required a bit of skill and finesse.

no. 1932 introduced a synchro gearbox on the 900.

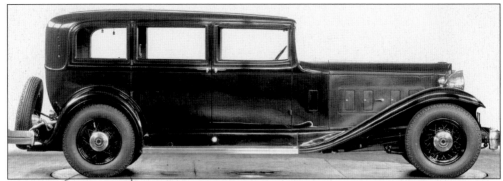

The massive town car, one of the largest vehicles Packard produced, was powered by Packard's legendary 12-cylinder engine.

No! This is a formal sedan. A town car has an open area for the chauffeur.

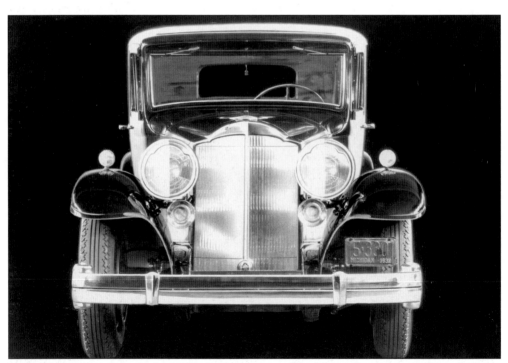

In this front view of the imposing Twin Six town car, the louvered radiator shell can be seen. As the engine heated up, these fins would open and allow more air to pass through the radiator. The absence of a radiator mascot should also be noted, as they are rarely seen without one. Packards were not equipped with them as standard equipment—they were available from the dealer at an extra charge.

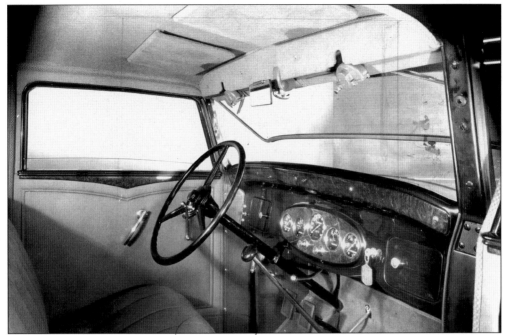

The enclosed cars, such as this 12-cylinder town car, were often fitted with windshields that opened for ventilation. Air conditioning was not available, and these big, enclosed cars needed as much ventilation as possible. *no! It is the interior of a 900 Sedan.*

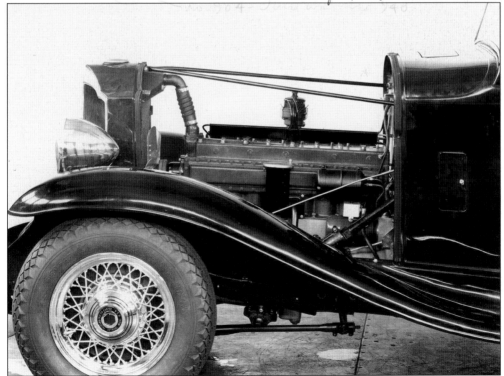

This photograph shows a side view of a 1932 eight-cylinder model with its hood removed.

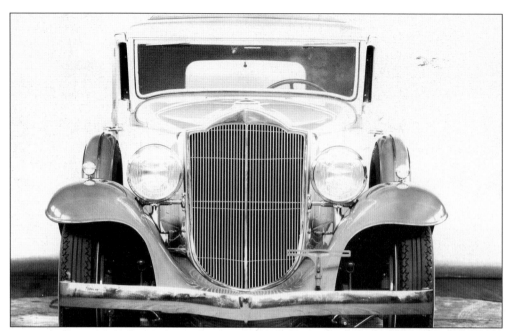

This unusual front end is characteristic of the Light Eight coupe, which was produced as an attempt to penetrate the mid-priced market. It was a more compact Packard equipped with small 17-inch wheels. Although very nicely appointed, it cost the factory the same to produce as the larger Standard Eight, which sold for hundreds more.

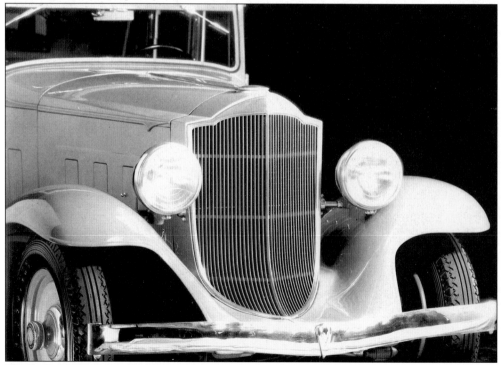

The Light Eight was praised for its quality and value, but Packard's inability to compromise any quality eventually led to the ~~company~~'s demise.

model's

This view of the Light Eight chassis shows how rugged it was—not something you would expect from an economy model.

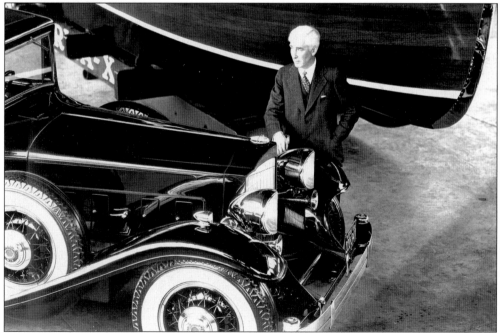

Gar Wood is pictured with a top-of-the-line 1932 sedan and the Packard-powered Miss America X speedboat. Packard had produced marine engines for many years, most famously for PT boats. The Miss America X was a flashy, high-performance speedboat that successfully marketed the strengths of the Packard marine engines. There is an interesting comparison between the shape of the Packard radiator and the bow of a speedboat.

121

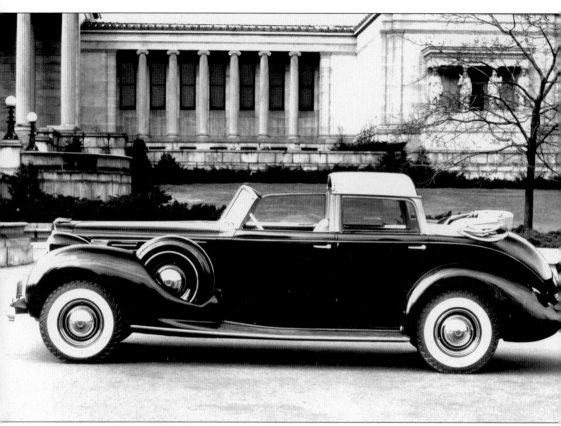

This photograph of a 1938 landaulet is the final and most recent in the collection. Packards were changing as American tastes changed. Although the company still produced elegant classic styles such as landaulets, the classic period was over and Packards would gradually become more conventional. The Packard name would be finished by 1957, but the classic cars would live on through the many enthusiasts and collectors preserving their history.

Six

RACING PACKARDS

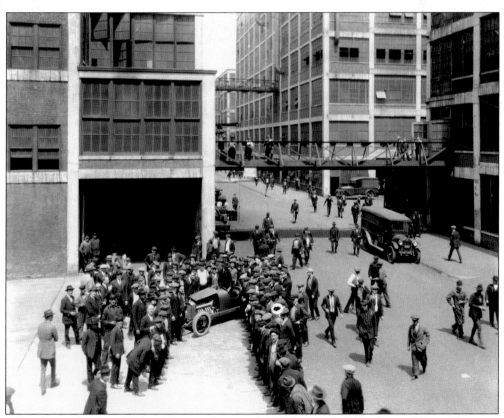

Actively involved in the developmental years of the sport, Packard had a small but rich racing history. Packard created some fascinating competition cars, and this photograph shows the unveiling of a Packard Indianapolis racer at the factory, creating great excitement.

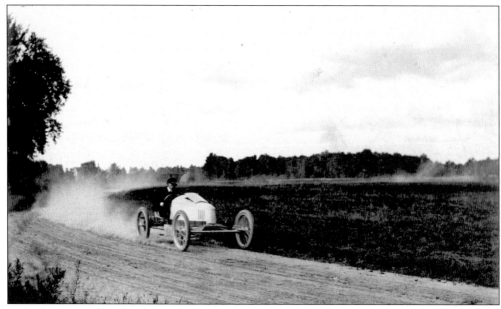

A 1904 Gray Wolf is shown speeding around a dirt track. This is one of the earliest of Packard's racing efforts, and its streamlined body was built on a spindly chassis and thin wire-spoked bicycle wheels. The Gray Wolf was capable of speeds of over 80 miles per hour. This is impressive especially considering that most vehicles at the time were barely able to reach 25 miles per hour.

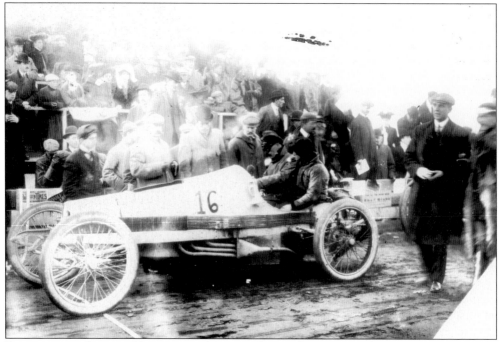

Bearing more of a resemblance to modern cars than it does to any of its contemporaries, the Gray Wolf design was remarkably advanced. Packard took a clean-slate approach to designing its racecars and did not just modify existing cars.

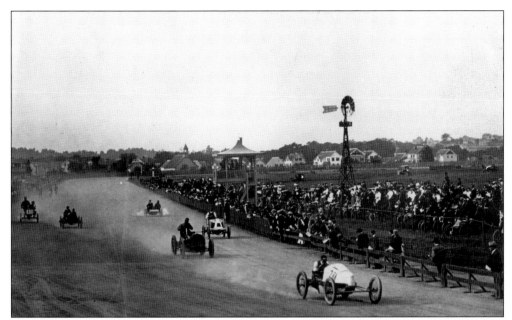

Although not a winner of major races, the Gray Wolf did place well in many important events. It gained respect for its consistently strong finishes despite having much less power than competing cars.

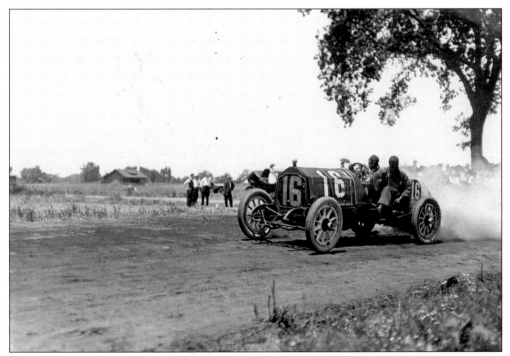

This is not the famous "Old 16" Locomobile but a similarly liveried Packard racer from the same time period. As it looks nothing like the factory-produced competition machines, this was likely a private racer that was created from a stripped and modified road car.

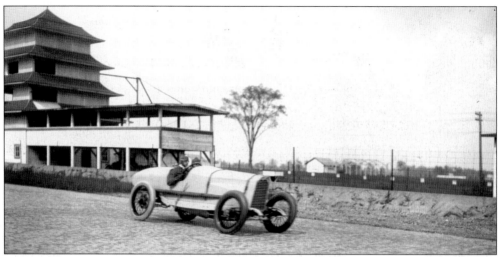

A Packard racer is shown speeding past the camera at Indianapolis. Packard's attempt at creating a racing-specific engine was not particularly successful, but adapting the Liberty aircraft engine for use in racing cars proved much more successful.

A Packard Special is pictured here rocketing across the brickyard. Three of these cars were Packard's entries in the 1923 Indianapolis 500. Ralph De Palma, Dario Resta, and Joe Boyer each piloted one of these, although all failed to finish. The engine was not related to any other Packard product—the 122-cubic-inch double overhead cam engine bears more similarity to Offenhauser than to Packard.

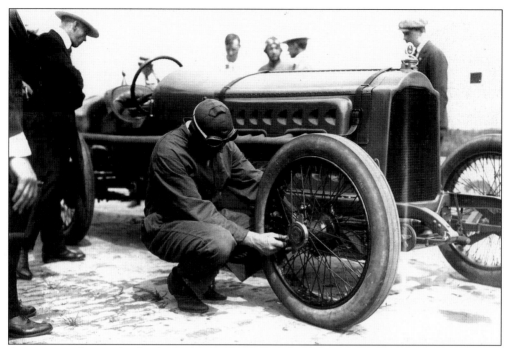

A racing mechanic checks the spoke tension before heading out in this aero-engine-powered Packard racer. Most early racecars were two-seaters: one for the driver and the other for the mechanic. Mechanical problems were so common that mechanics were brought along to keep the car running and to navigate.

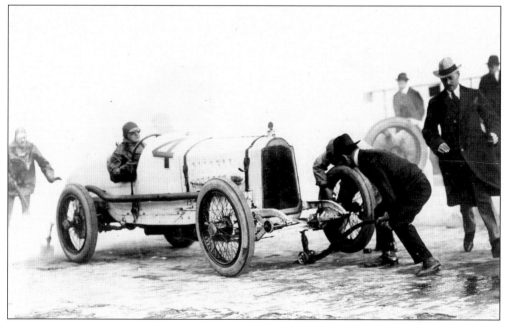

A quick wheel change for the No. 4 Packard racecar includes the use of an early speed jack by the formally attired pit crew. Tire and wheel failure was commonplace in early competition, when drivers raced on fragile equipment designed for passenger cars.

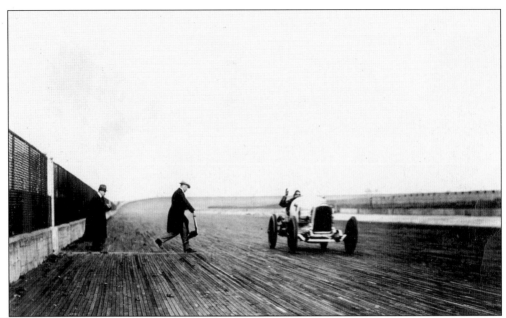

Speed trials in a Liberty aero-engine-powered Packard racer. Packard achieved great racing success with its airplane-engine-powered racecars. Note the crude construction of the board track.

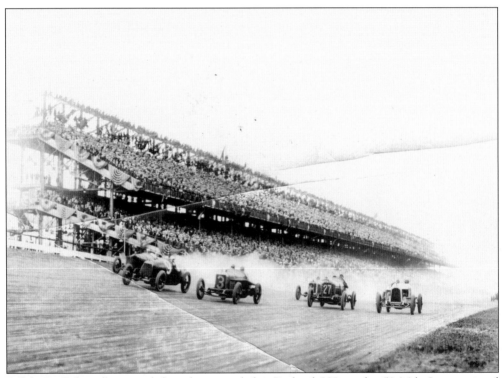

Ralph De Palma (lower right) is shown with his Packard 299 in the 50-Mile International Sweepstakes at Sheep's Head Bay on June 14, 1919. De Palma won with a new world record time—a great achievement for the airplane-engine-powered Packard.